The College History Series

HUNTER
COLLEGE

HUNTER COLLEGE

WE ARE OF DIFFERENT OPINIONS
AT DIFFERENT HOURS BUT WE
ALWAYS MAY BE SAID TO BE, AT
HEART ON THE SIDE OF TRUTH

RALPH WALDO EMERSON

This quotation from Ralph Waldo Emerson was chosen by Hunter College Pres. George N. Shuster to grace the 68th Street side of the Hunter College North building.

The College History Series

HUNTER COLLEGE

JOAN M. WILLIAMS

ARCADIA

First printed 2000

Published by Arcadia Publishing,
an imprint of Tempus Publishing, Inc.
2 Cumberland Street
Charleston, SC 29401

Printed in Great Britain.

Library of Congress Catalog Card Number: 99-069229

For all general information contact Arcadia Publishing at:
Telephone 843-853-2070
Fax 843-853-0044
E-Mail sales@arcadiapublishing.com

For customer service and orders:
Toll-Free 1-888-313-2665

Visit us on the internet at http://www.arcadiaimages.com

CONTENTS

ACKNOWLEDGMENTS

This book would not have been possible without the help of a number of people in collecting photographs and information. I am particularly grateful to Prof. Julio Hernandez-Delgado, archivist of the Hunter College Library, who was so helpful in allowing me full access to the photograph collection. I also want to thank Jean Sadowsky, director of the Hunter College Office of Publications; Janet B. Munch of the Lehman College Library; Tatiana Manvelidze, reference librarian, and Irene Schaeffer of the Hunter College School of Social Work; Eli Schwartz of the Hunter College Alumnae/i Association; Damian Jones of the Hunter College Athletic and Recreation Programs Department; Frances McGregor Leister; and Terry Speciale. Thank you all.

My sources included ECHO 1995 and articles by Janet Munch and Jean Sadowsky, as well as material in the Hunter College Library Archives.

Unless otherwise noted, images are from the archives of the Alumni Association of Hunter College, 1872–1997.

INTRODUCTION

Hunter College Highlights

Free public higher education for women was offered for the first time in New York City when Hunter College opened in 1870 as the Female and Normal High School. Until then, women began teaching careers, with little or no training, after completing the eighth grade. Dr. Thomas Hunter, who became the Female and Normal High School's first president, argued that teachers should have intellectual preparation as well as pedagogical training. Two years of academics would satisfy those who did not wish to pursue a teaching career. A third year of pedagogy and practice teaching prepared future teachers.

The school opened over a carriage shop with 1,000 girls averaging 14 years of age. The faculty of seven men, including Dr. Hunter, was augmented by female tutors and assistants supervised by Lydia Wadleigh, lady superintendent. The curriculum included several languages, ancient history, intellectual philosophy and rhetoric, theory and practice of teaching, and physics and physiology. A semester of practice teaching followed in the newly opened Normal College Training Department, later known as the Model Elementary School. The Training Department also provided the first free public kindergarten in the United States.

Dr. Hunter set the tone and purpose of the college at its very beginning. He noted that "the training school is as necessary to the teacher as the dissecting room to the surgeon." With that in mind, Arthur Dundon, vice president and professor of Latin and English, chose the school motto: *Mihi Cura Futuri*—to me is the care of the future.

Dr. Hunter insisted that the college be open to all young women who qualified through competitive examination, regardless of race, religion, or social class. The school "must admit colored and white girls on equal terms," he said, even though New York's public schools remained segregated. On the other hand, married women were banned from the college. Students would be dropped "the moment they marry," he said.

The first commencement of 96 students was held in June 1870 at the Academy of Music.

Because of the large number of students, classes were housed in various locations around the city. The school needed a home of its own. Dr. Hunter drew the plans for what was now called the Normal College, which opened in October 1873 on Park Avenue between 68th and 69th Streets.

Although not regents accredited, the first bachelor of arts degrees were awarded in June 1892. By then, there were two courses of study. A four-year program led to a certificate and a teaching

license. The five-year course granted a diploma and the bachelor of arts degree.

The Class of 1902 was the first to wear caps and gowns, but it wasn't until 1909 that the faculty marched in full academic regalia at commencement. Full accreditation of the bachelor's degree was awarded to Hunter College in 1908.

Preparing public school teachers was the sole aim of the Normal College but in 1882, Dr. Hunter advised establishing additional programs. He suggested the introduction of classical, business, and art courses, which would "furnish in the end a superior class of teachers and would certainly enable those students who had no taste for teaching to earn a living in other walks of life."

The Normal College became Hunter College in 1914, honoring Dr. Hunter, its inspiration and its first president.

During the 1920s, branches were established in the Bronx, Brooklyn, and Queens; a Phi Beta Kappa chapter was introduced. In 1933, the four Bronx Campus buildings were opened. The Park Avenue building burned in 1936, and its replacement was dedicated in 1940.

During World War II, the Bronx Campus was taken over by the U.S. Navy as a training center for Waves (Women Accepted for Voluntary Emergency Service). The navy dubbed the site "USS Hunter." Then, for three months in 1946, the Bronx Campus was the site of the first regular sessions of the United Nations Security Council and General Assembly. The campus later became independent and was renamed Lehman College of the City of New York, honoring Herbert H. Lehman, the former New York State governor and senator.

Roosevelt House, a double house residence of Sara Roosevelt and the Franklin Delano Roosevelt family at 47 and 49 East 65th Street, was acquired by the Hunter College Student Social, Community, and Religious Clubs Association in 1943. Headquartered there were the Hillel Foundation, the House Plan Association, the Hunter College Protestant Association, the Newman Club, the Pan-Hellenic Association, and the Toussaint L'Ouverture Society. The Alumni Association and the Association of Neighbors and Friends also had offices there. The house was used until 1992, when it was closed for financial reasons. In 1997, it was turned over to the Hunter College Foundation Inc.

Following World War II, veterans entered Hunter under the GI Bill. Actual coeducation first came to Hunter in 1951 at the Bronx Campus and then at Park Avenue in 1964. Through the years, Hunter has grown in scope, programs, and student body. Summer sessions, evening and extension sessions, the School of Social Work, the School of Nursing, the Institute of Health Sciences, and research centers such as the Brookdale Center on Aging and the Centers for AIDS, Health, and Family Policy have been added.

Enrollment in 1999 numbered over 15,000 undergraduate and 4,000 graduate students. Hunter graduates have won Fulbright and Mellon fellowships, two Nobel prizes, and numerous other awards.

And it all began with 1,000 students, 129 years ago.

—Joan Meyer Williams
Class of 1952

One
BEGINNINGS

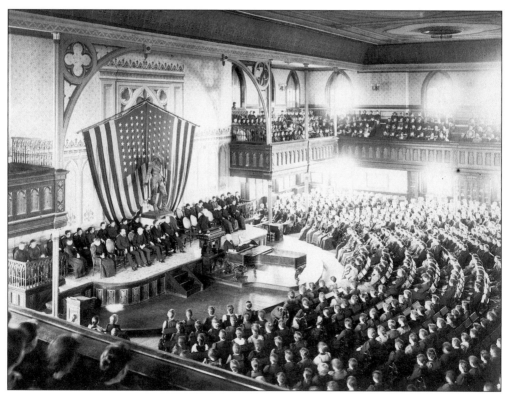

Commencement exercises for the Normal College were held here in the chapel after 1873. Prior commencements took place at the Academy of Music.

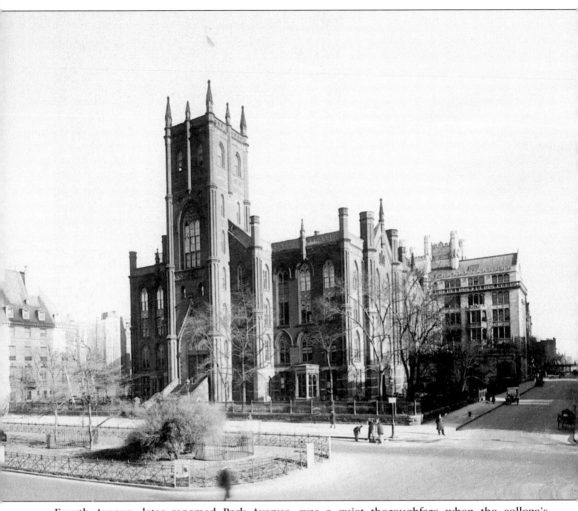

Fourth Avenue, later renamed Park Avenue, was a quiet thoroughfare when the college's first building opened between 68th and 69th Streets in 1873. Helen Gray Cone, Class of 1876, later remembered that "goats roamed around the barren neighborhood. . . . There were vacant lots from Fifth to Third Avenues. . . . But to the girls of 1873, our building was . . . spacious and magnificent."

This 1917 photograph shows an impressive main entrance to the Normal College on Park Avenue.

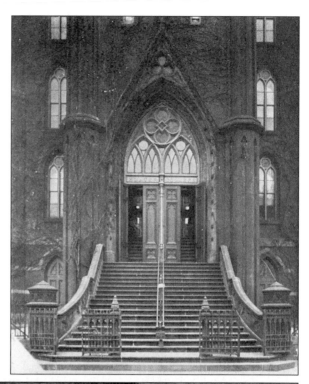

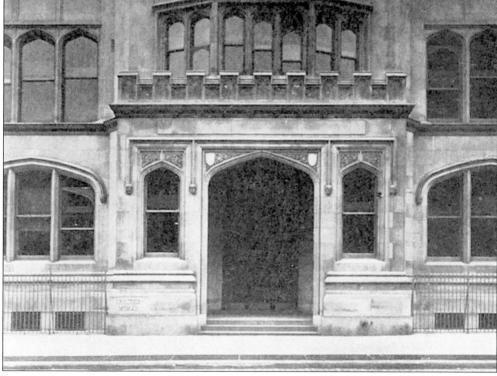

The Lexington Avenue building of the Normal College eventually became the home of the Hunter College High School. This photograph was taken *c.* 1917.

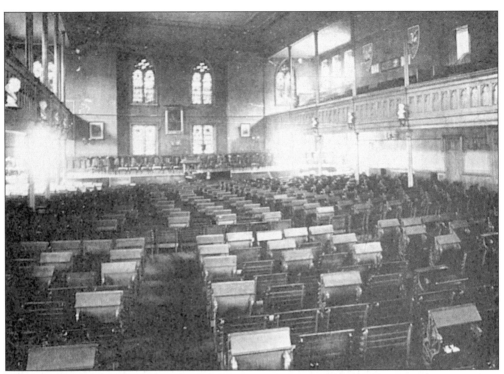

Every morning the students met in the chapel. This photograph was taken in 1917.

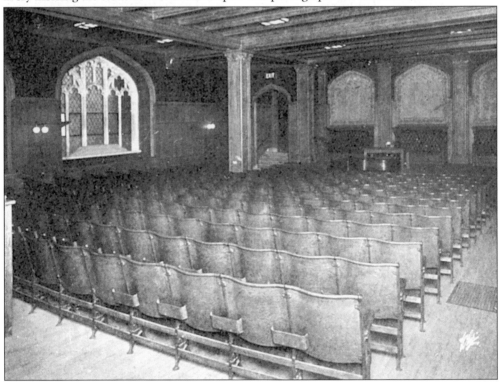

This image of the auditorium was photographed in 1917.

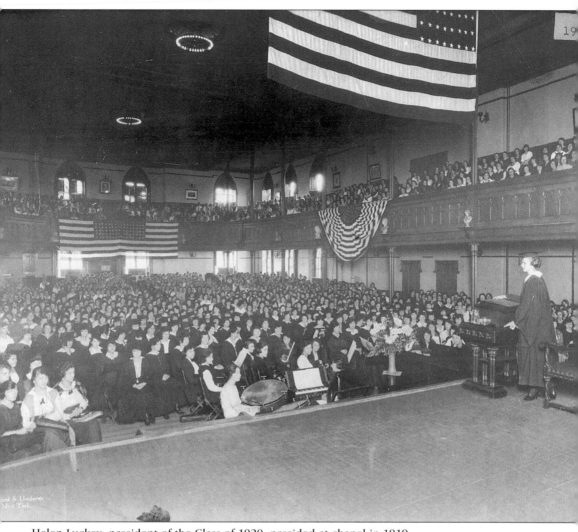

Helen Luckey, president of the Class of 1920, presided at chapel in 1919.

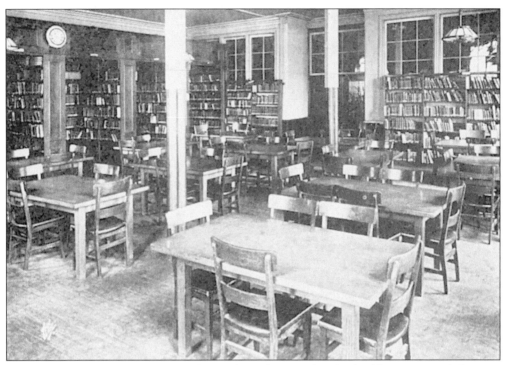

The main library had ample space for study and research. The building appeared this way in 1917.

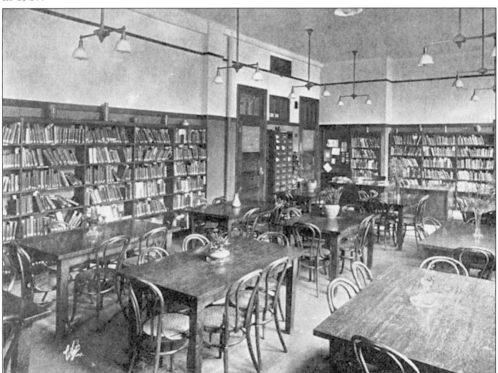

This 1917 image shows the hygiene library, which was an additional resource.

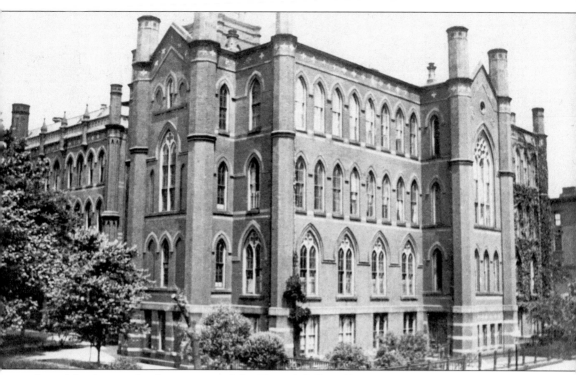

A model primary school, soon named the Normal College Training Department, provided the first public kindergarten in the United States. This view was photographed *c.* 1900.

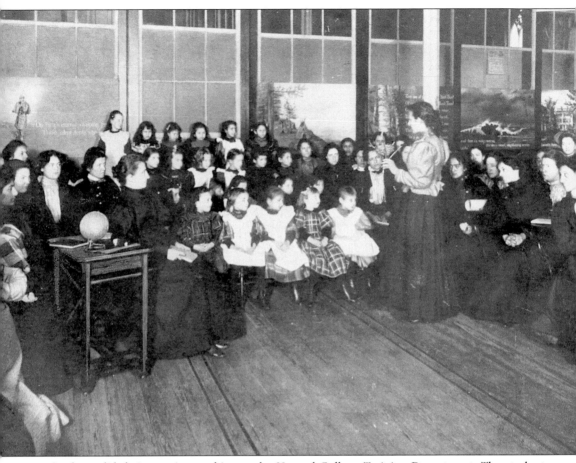

Students did their practice teaching at the Normal College Training Department. The student teacher here appears to be under observation by faculty members and her peers in 1890.

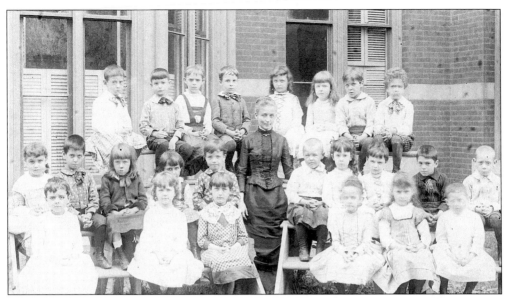

Members of a kindergarten class at the Normal College Training Department pose with their teacher.

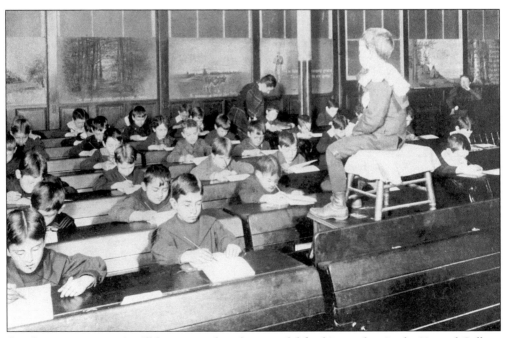

One boy manages to sit still long enough to be a model for his art class in the Normal College Training Department, *c.* 1900.

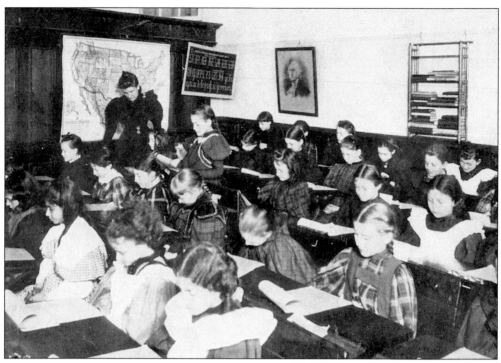

A Normal College Training Department class is hard at work in 1897.

𝔐𝔬𝔡𝔢𝔩 𝔖𝔠𝔥𝔬𝔬𝔩

𝔥𝔲𝔫𝔱𝔢𝔯 ℭ𝔬𝔩𝔩𝔢𝔤𝔢 𝔬𝔣 𝔱𝔥𝔢 ℭ𝔦𝔱𝔶 𝔬𝔣 𝔑𝔢𝔴 𝔜𝔬𝔯𝔨

𝔗𝔥𝔦𝔰 ℭ𝔢𝔯𝔱𝔦𝔣𝔦𝔢𝔰 that *Pearson Halstead Kipp*

has completed, in this 𝔖𝔠𝔥𝔬𝔬𝔩, the first five years of the prescribed elementary course of study, and by scholarship and good conduct has merited the approbation of his Instructors.

June 16, 1920

Mary C. McGuire
Principal 𝔐𝔬𝔡𝔢𝔩 𝔖𝔠𝔥𝔬𝔬𝔩

Young Pearson Halstead Kipp earned the "approbation of his instructors" in 1920 by virtue of scholarship and good conduct at the Normal College Training Department, now called the Model School. (Courtesy J.M. Williams.)

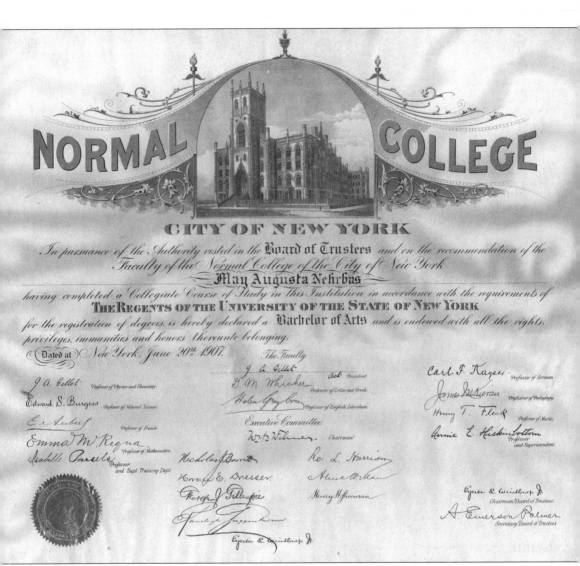

May Augusta Nehrbas was awarded a bachelor of arts degree from the Normal College, City of New York, in 1907. (Courtesy J.M. Williams.)

Department of Education
The City of New York

Elementary Schools—License No. 1 or Grade B

This is to Certify, That _May A. Nehrbas_

having passed the required tests of character, scholarship and general fitness, this License No. 1 (Grade B) is hereby issued to h__er__ to act as **Grade Teacher in the Elementary Schools** of The City of New York, for the period of one year from the date of appointment, subject to the By-Laws of the Board of Education.

Witness my hand and the seal of the Board of Education this ___15th___ day of _October_ 1907.

City Superintendent of Schools.

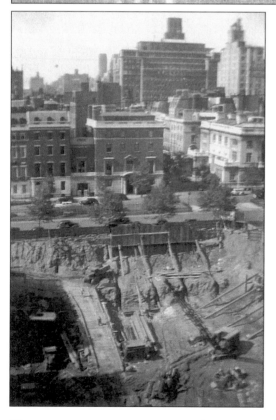

After graduating from the Normal College, May A. Nehrbas earned her license as a "Grade Teacher in the Elementary Schools of the City of New York" in 1907. (Courtesy J.M. Williams.)

Construction begins here at the new Hunter College Park Avenue site.

The main entrance on Park Avenue is used mainly by visitors; students enter from the subway and bus on Lexington Avenue or 68th Street. This view was photographed *c.* 1941.

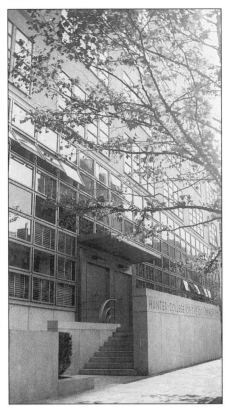

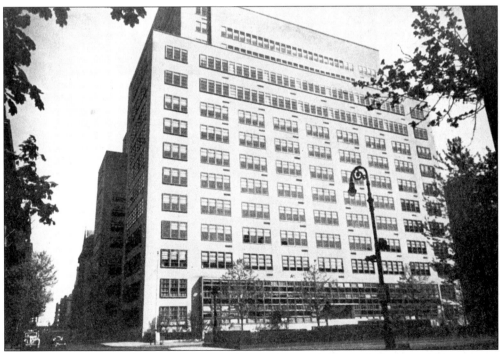

The finished product at 695 Park Avenue is the new home of Hunter College, *c.* 1941.

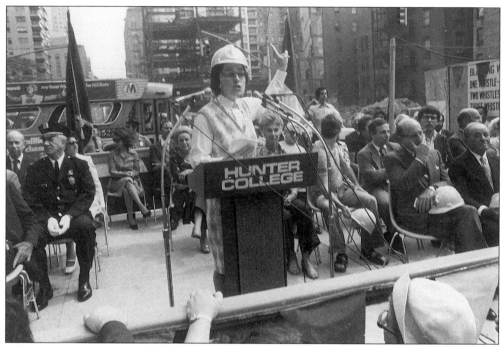

College Pres. Jacqueline Grennan Wexler dedicates the site of Hunter's new twin towers in this 1974 photograph.

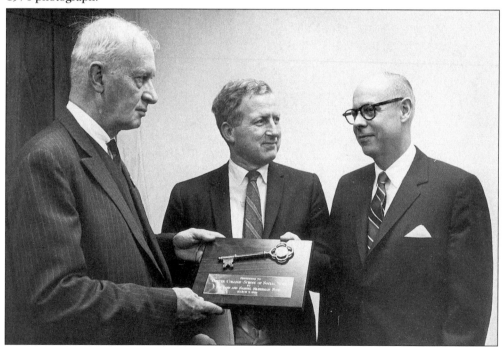

Samuel Silberman, right, presents the key of the School of Social Work to college Pres. Robert Cross, center, in 1969. Porter Chandler of the Board of Higher Education stands on the left. Funding for the building, located at Lexington Avenue and 79th Street, was provided by the Lois and Samuel Silberman Fund.

Two
STUDENTS

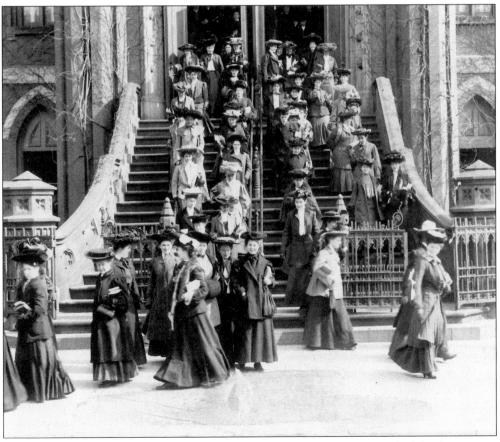

In 1890, students were required to leave the school in procession at the end of the day.

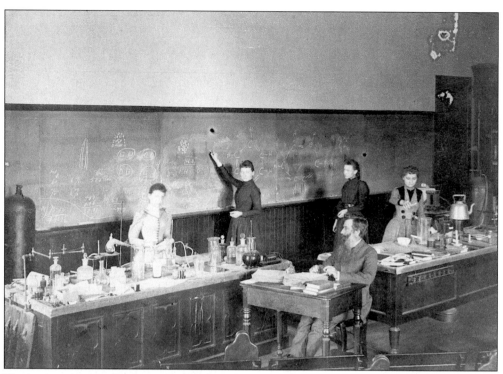

Physics was a required subject at Hunter in 1878.

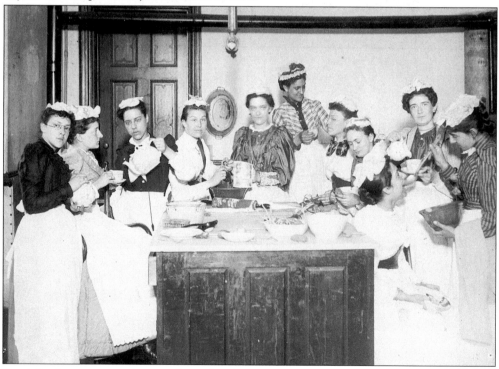

Specialized courses—such as cooking, for domestic science teachers—were offered to highly qualified graduates. These students had met the criteria in 1878.

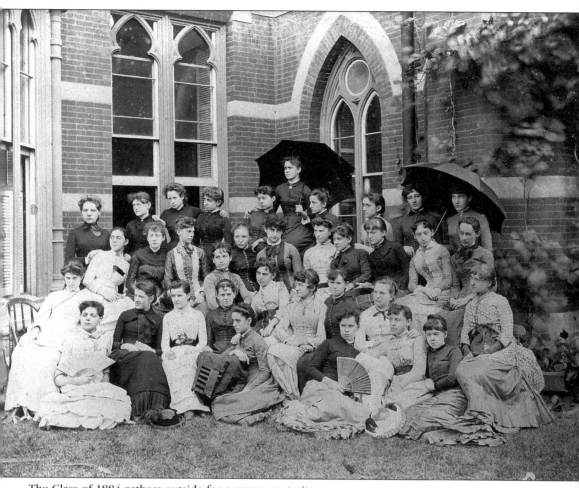

The Class of 1884 gathers outside for a group portrait.

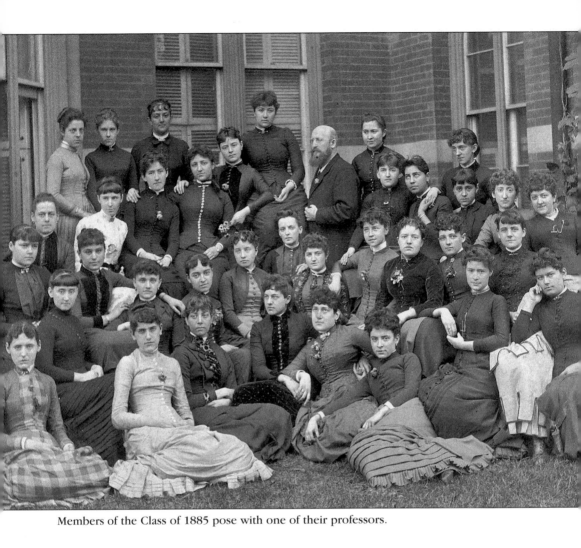

Members of the Class of 1885 pose with one of their professors.

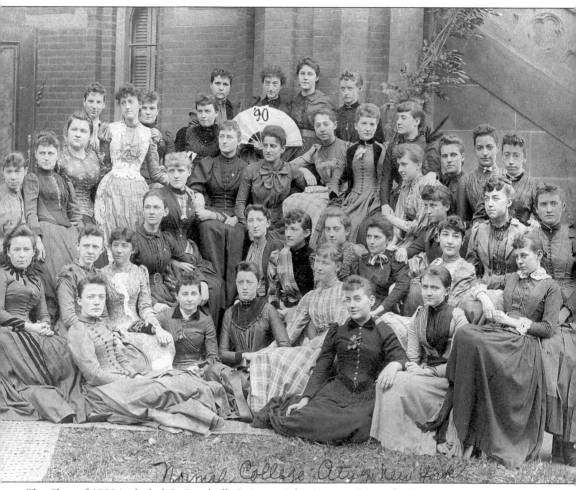

The Class of 1890 included C. Goodsell, O. Jones, Edna Turner, Gertrude Turner, Naomi Morris, D. Taylor, ? Duffy, ? Heath, Gertrude Mirick, Lucy Duffy, Annie Crosson, Miss Harris, Miss Harrison, Miss Kirby, M.E. Bole, Alice Murphy, M. Lambert, and R. Oppenheimer.

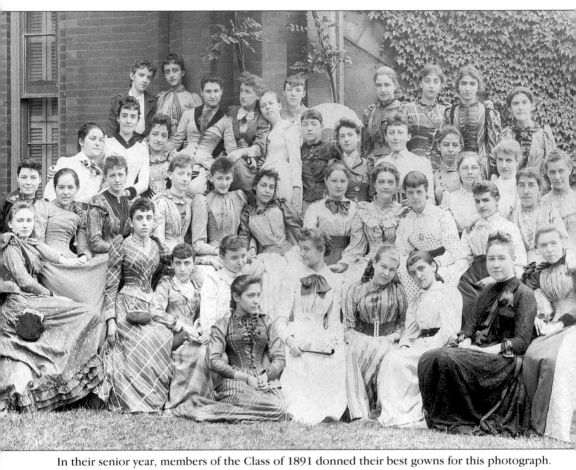

In their senior year, members of the Class of 1891 donned their best gowns for this photograph.

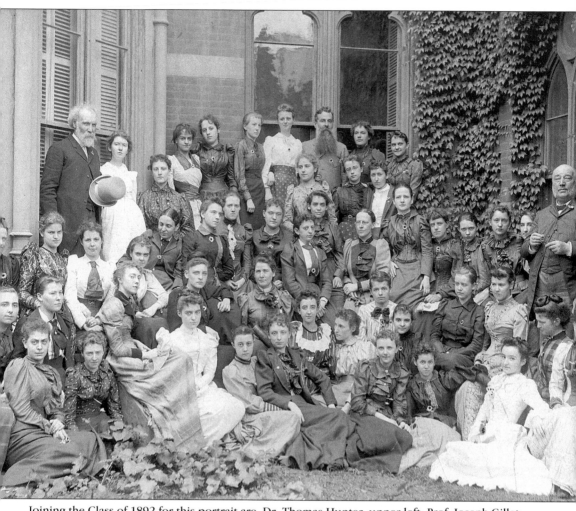

Joining the Class of 1892 for this portrait are, Dr. Thomas Hunter, upper left; Prof. Joseph Gillet, back row, third from right; Prof. Helen Cone, seated on the left of the next row down; and Prof. Arthur Dundon, standing at the far right. Alice E. Leonard is seated second from right.

A demure Marguerite Merington, later president of the Alumnae Association, is shown here in 1891.

The Normal College Alumnae Association, as a social service activity, sponsored a free kindergarten, which was the forerunner of the Lenox Hill Settlement House. Mary A. Wells, director of the program, is shown here in her office, c. 1890.

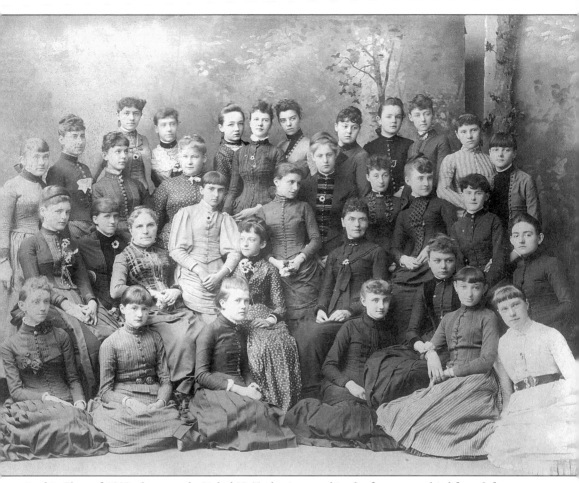

In this Class of 1893 photograph, Mabel H. Taylor is seated in the front row, third from left.

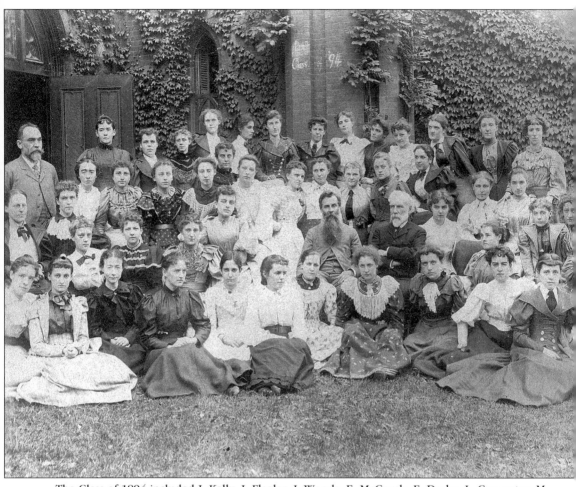

The Class of 1894 included J. Kelly, J. Flagler, I. Woods, E. McComb, E. Derby, L. Carpenter, M. Griffiths, J. Lippman, E. Fogal, C. Kruger, M. Boldt, J. Moritz, A. Grimm, A. McKean, T. Auerbach, E. Morris, M. Rensen, M. Clayton, N. Walsh, E. Lynch, A. Connellon, C. deAguero, S. Nash, B. Mayers, and S. MacDougall. Dr. Thomas Hunter is in the second row, third from right. Joseph Gillet sits next to him.

Martha H.C. Boldt holds an elegant pose in 1894.

Members of a Latin class sit at attention for this photograph taken in 1897.

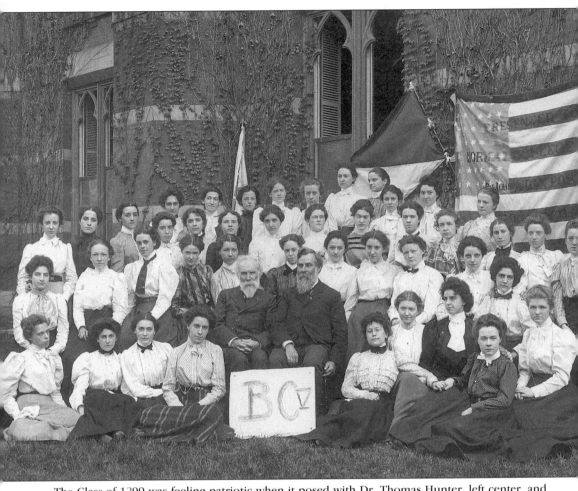

The Class of 1899 was feeling patriotic when it posed with Dr. Thomas Hunter, left center, and Prof. Joseph Gillet, right center.

Some members of the Class of 1897 gather for this nicely arranged photograph.

A biology class in 1912 took time for a photograph.

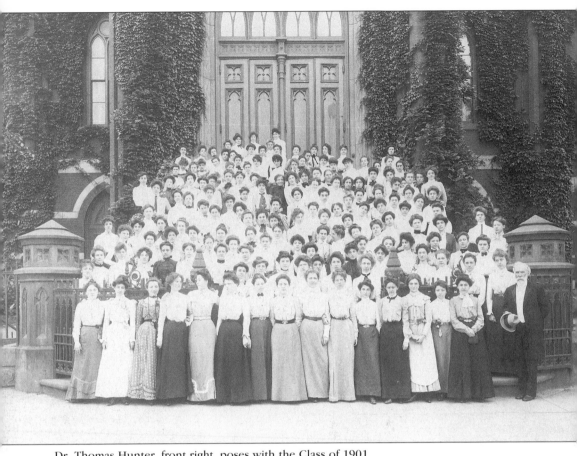

Dr. Thomas Hunter, front right, poses with the Class of 1901.

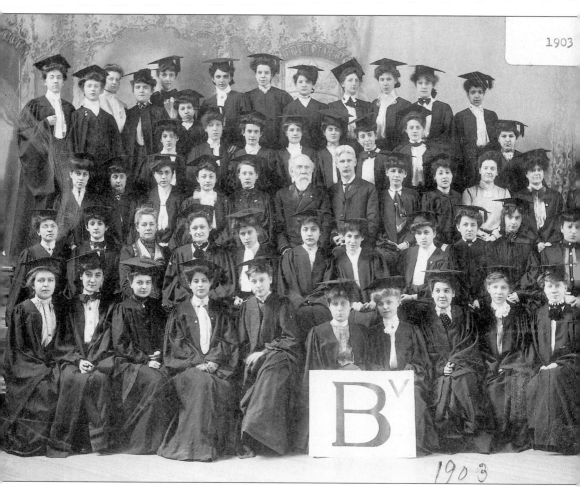

1903

1903

The Class of 1903 donned caps and gowns for this photograph with Dr. Thomas Hunter and Prof. George Whicher, third row center.

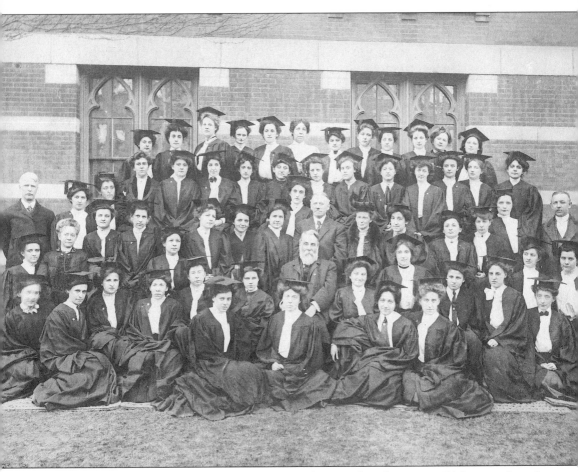

Prof. Joseph Gillet sits in the center of the second row and Prof. George Whicher stands at the far left in this photograph of the Class of 1907.

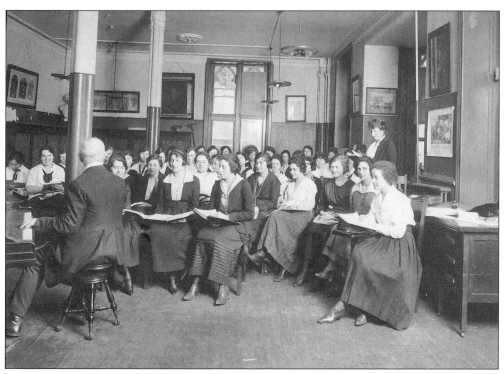

Prof. Henry Fleck has the full attention of his music class in this 1914 photograph.

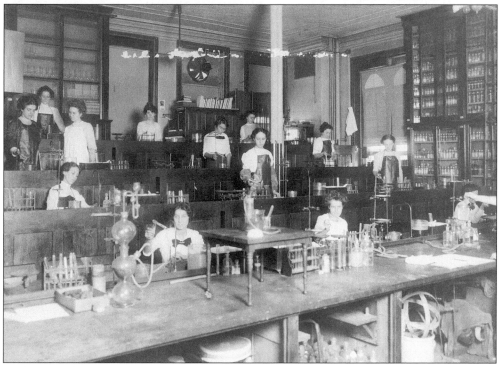

Students in the physical science class work in their well-equipped (for that time) laboratory in 1915.

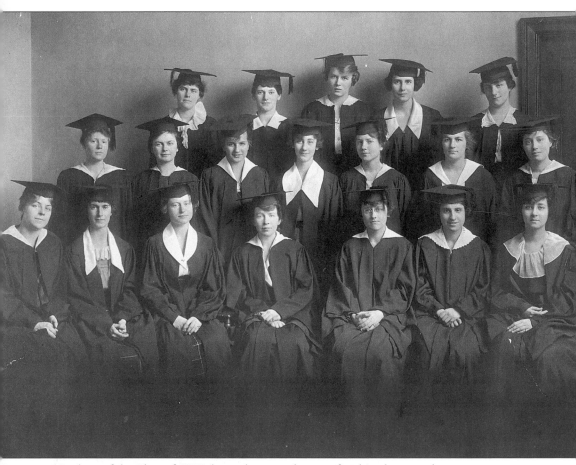

Members of the Class of 1915 donned caps and gowns for this photograph.

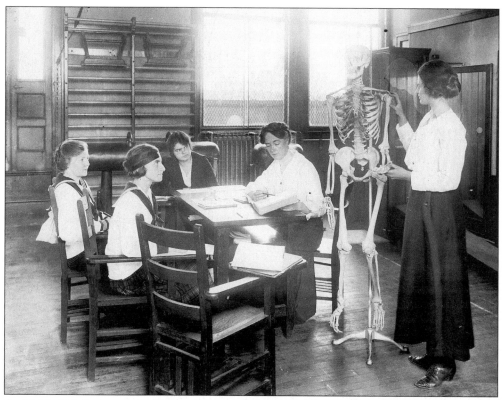

Prof. Mabel H. Taylor, second from right, taught anatomy. She established a scholarship fund to provide grants to the Department of Health and Physical Education.

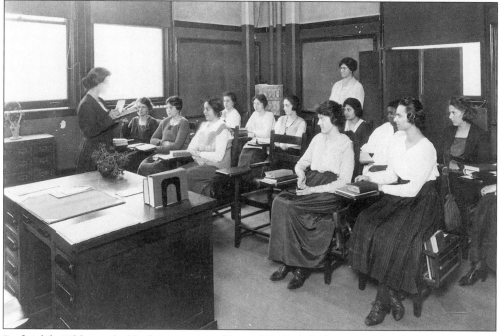

Prof. Adele Bildersee holds the attention of her 1920 English class.

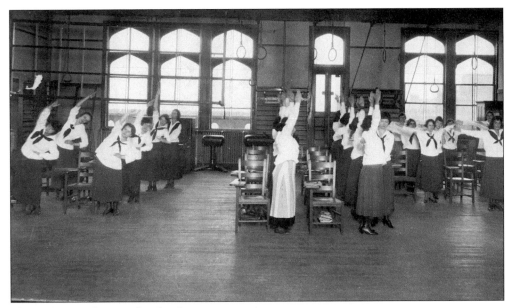
This 1920 gym class reaches for the stars.

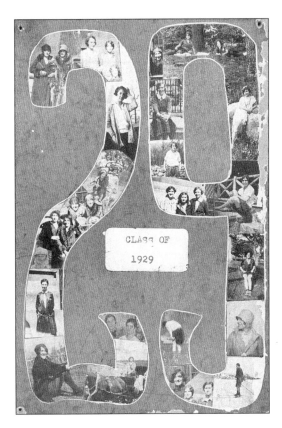
The Class of 1929 mounted vignettes of class members in a novel way.

The Class of 1925 preserved some
memories for posterity.

Ida Baron of the Class of 1925 was
president of the senior class.

One of the many pairs of mothers and daughters who graduated from Hunter are Martha Gottesman Hoffman, left, of the Class of 1927 and Anne Hoffman, right, of the Class of 1964.

"Miss Louise" celebrates her 102nd birthday in 1965. At the time, she was one of the oldest living alumnae.

In 1949, 94-year-old Harriet Rutter Eagleson, left, of the Class of 1871 was the oldest living alumnae. With her is Sybil Lamb of the Class of January 1949 at that year's alumnae luncheon.

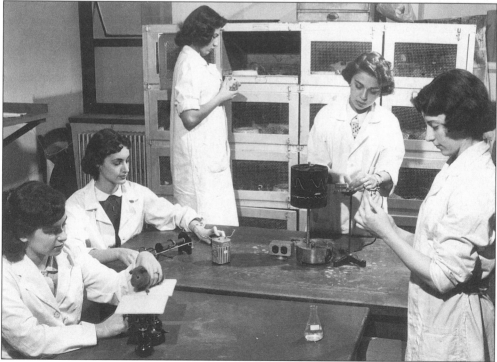

Physiology students prepare for the study of the autonomic nervous system of the guinea pig. Seen in this 1953 photograph, from left to right, are Barbara Berger, Sonia Kroland, Evelyn Fluss, Murial Yanow, and Zina Camarda.

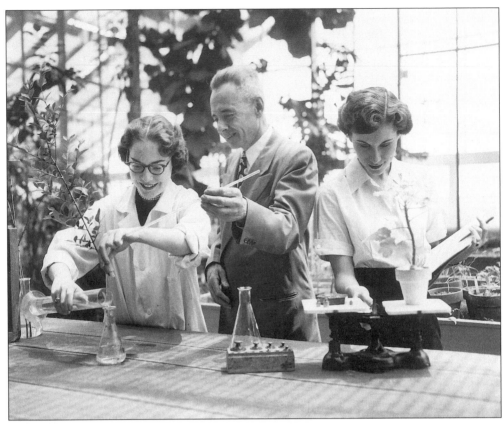

In the plant house on the 15th floor, Prof. Harold H. Clum directs plant physiology students in an experiment to show transpiration of water through the leaves. Hannah Sussman, left, sets up the experiment while Barbara Brodmerkel, right, weighs a plant to measure transpiration rate.

Three
BRONX CAMPUS

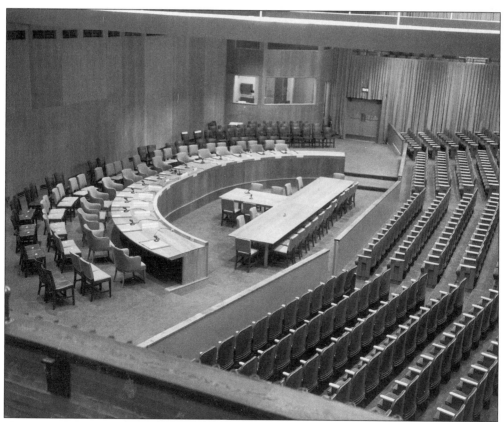

The Bronx Campus gymnasium is shown here after its conversion into a meeting room for the United Nations General Assembly. The assembly held its first regular session here on March 4, 1946.

Davis Hall at the new Bronx Campus was named for George Samler Davis, former president of Hunter College, *c.* 1930.

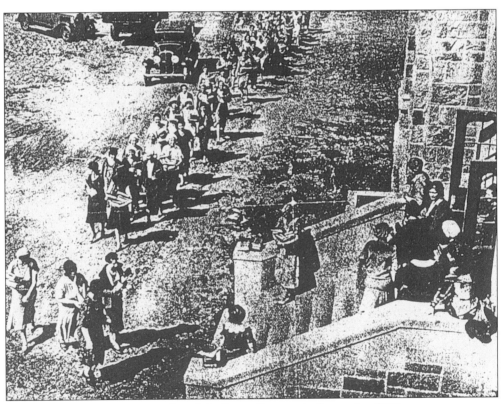

Students stream in on opening day of the Bronx Campus in September 1931.

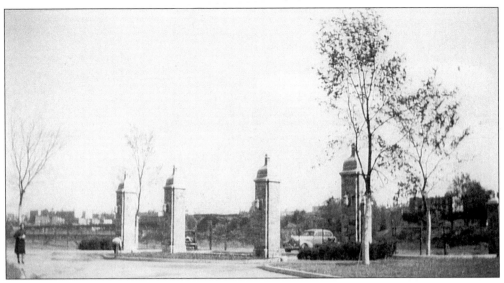

The campus look of the Bronx buildings was a big plus for many students from city apartments, from the time they walked through the entrance. This photograph was taken *c.* 1939.

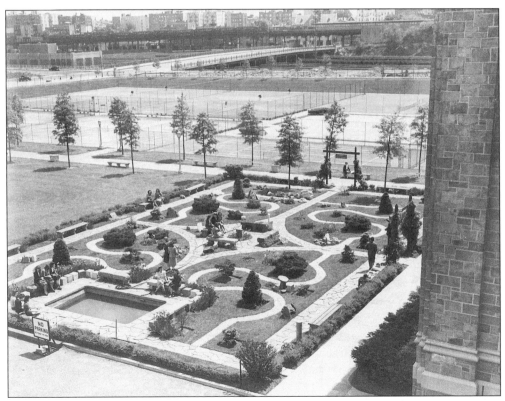

Lehnerts Rock Garden was a pleasant place to sit during a free period. The garden honored Geology Prof. Edward Lehnerts.

Student Hall was the place to relax and meet friends. This photograph of the hall was taken *c.* 1950.

Attending a Christmas party in December 1932 are college Pres. James M. Kieran, fifth from left; Mrs. Maxwell Hall Elliot, dean, far left; Prof. Lewis D. Hill, head of the Department of Physical Science; Board of Trustees members Dr. Harry Swift, Dr. Lawrence Cassidy, and Mrs. Michael Mulqueen; Dean Annie E. Hickinbottom, sixth from left, and students.

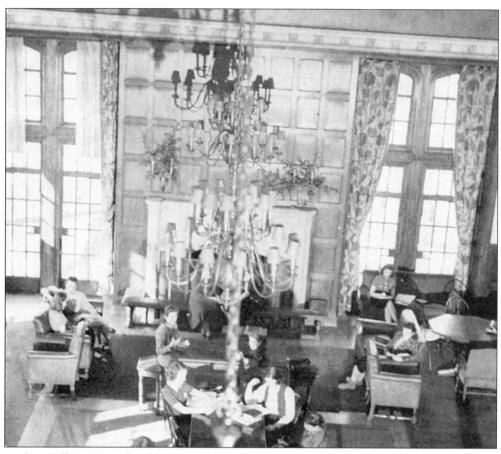

Student Hall was a comfortable setting for studying or socializing.

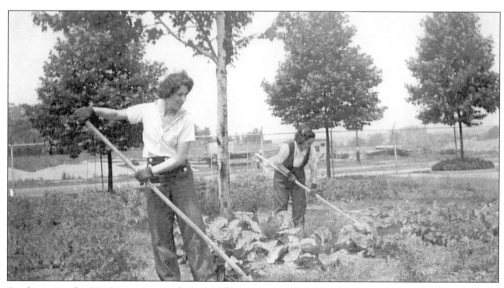

Students tend a WWII victory garden *c.* 1942.

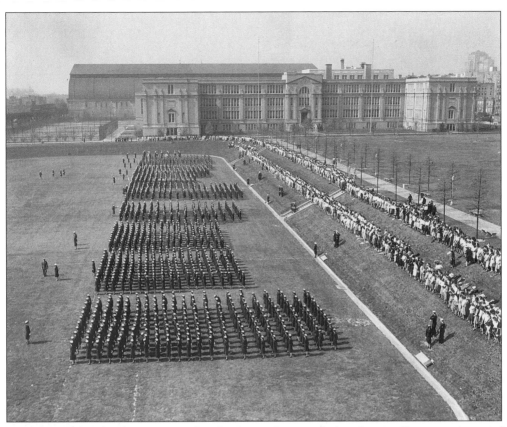

A naval training school was stationed at the Bronx Campus during the war. Here, a regiment of 2,000 Waves (Women Accepted for Voluntary Emergency Service), Spars (the women's auxiliary of the U.S. Coast Guard, from whose motto *Semper Paratus* came the acronym), and Marines are being reviewed by navy Adm. E.J. Marquart. (Official U.S. Navy photograph, 1943.)

The Bronx gymnasium is converted into a meeting room for the United Nations in 1946.

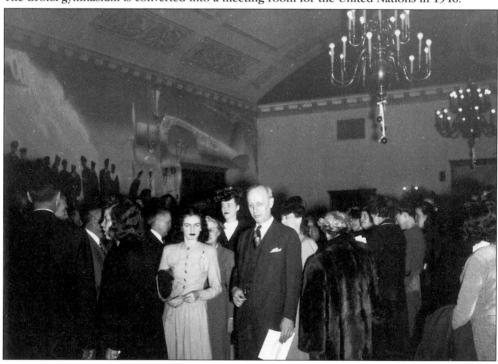

Helyn Quinn, president of the freshman class, escorts college Pres. George Shuster to the Christmas fire-lighting ceremony in Student Hall. The ceremony was the first of its kind after the war and after the campus's occupation by the Waves and the United Nations. The mural in the background shows servicemen of various nations; it had served as an identification test for the Waves. This photograph was taken on December 23, 1946.

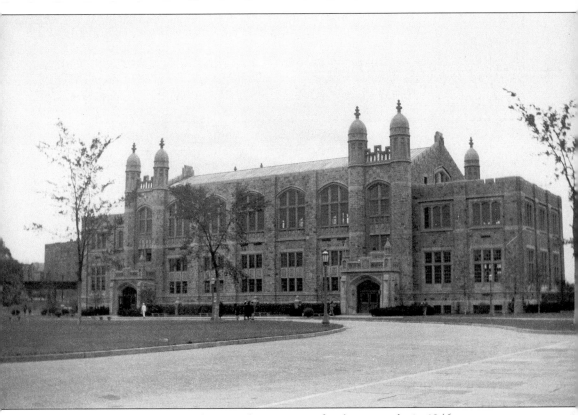

This was the gymnasium where the United Nations met for three months in 1946.

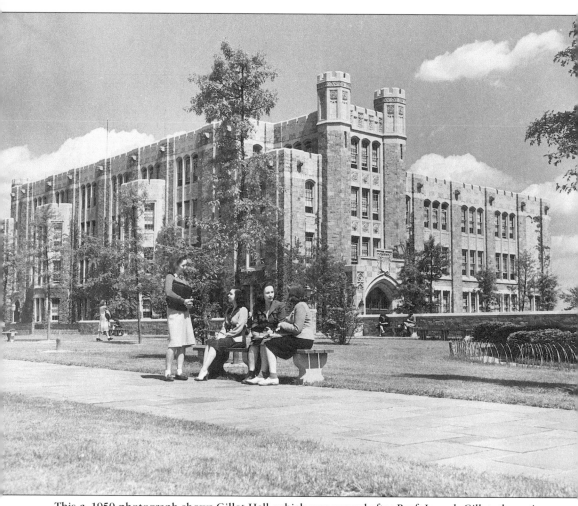

This *c.* 1950 photograph shows Gillet Hall, which was named after Prof. Joseph Gillet, the acting president of the Normal College who succeeded Dr. Thomas Hunter.

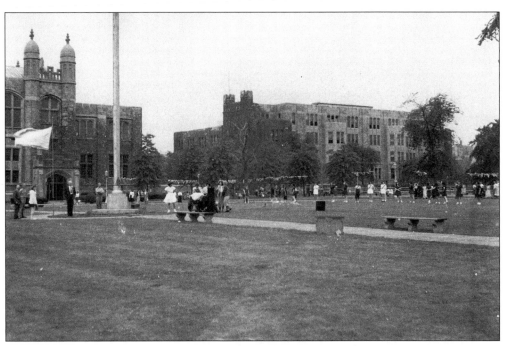

The athletically inclined participated in this Field Day, *c.* 1949.

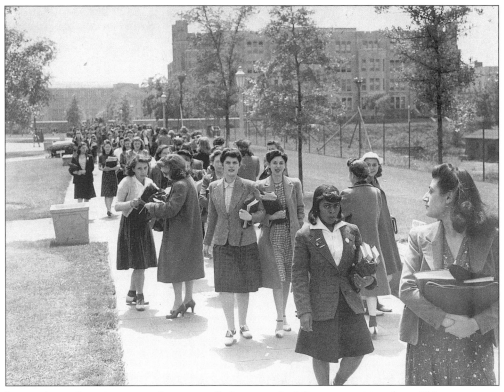

In good weather, it was a pleasant walk between buildings to get to class. This scene was photographed *c.* 1950.

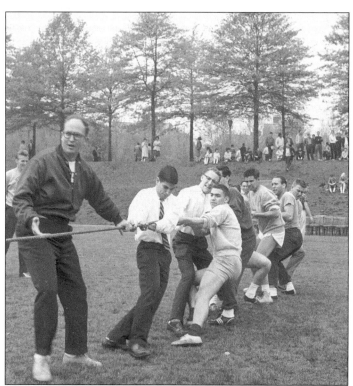

This tug-of-war could well have been during a Field Day in the 1950s.

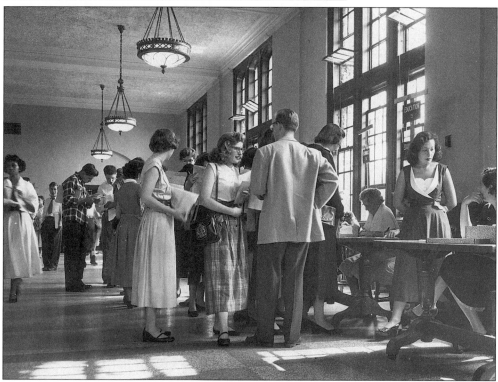

Registration day meant standing in one line after another, as seen in this 1951 photograph.

Could this be "gym garb through the ages"? These students were photographed c. 1950.

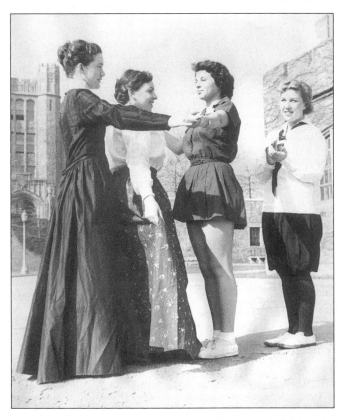

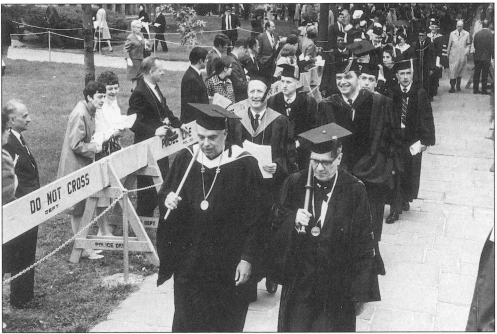

College Pres. Robert Cross, second row, leads the commencement procession in this photograph taken in 1968.

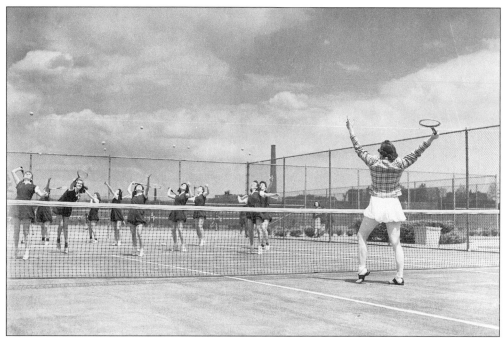

Tennis was played in bloomer-style gym suits in the 1950s.

Club Day was the time to choose extracurricular activities.

Four

WAR YEARS

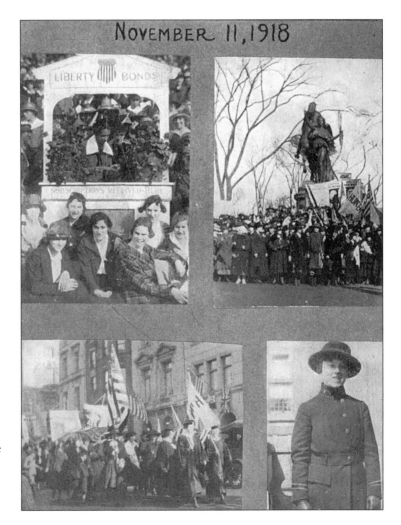

Hunter celebrates the
Armistice along with
the rest of
the country on
November 11, 1918.

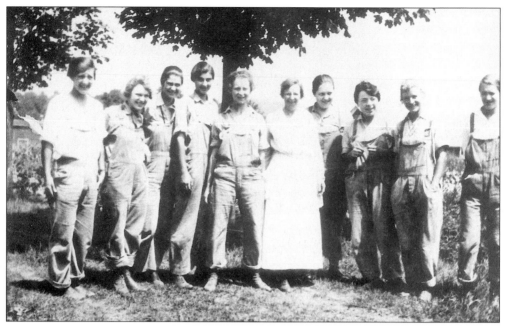

In 1918, "farmerettes" got their hands dirty and used horse-driven farm machinery to help feed the nation during World War I.

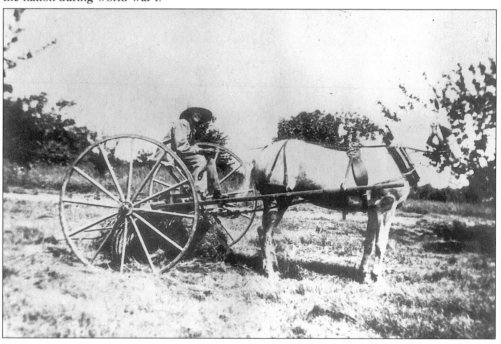

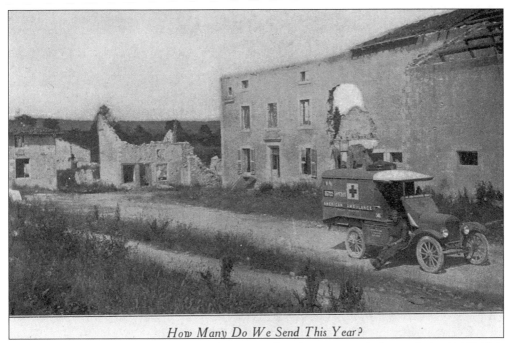

How Many Do We Send This Year?

Hunter College gifted the American Red Cross with at least one ambulance during WWI. This image was photographed *c.* 1917.

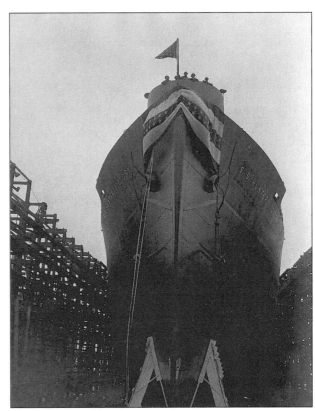

During WWII, many new merchant ships, dubbed Victory ships, were named after colleges and universities. This ship, photographed on May 12, 1945, was officially named the USS *Hunter Victory*.

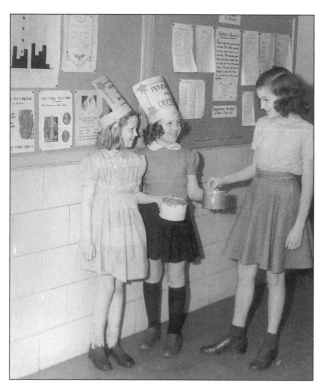

The Hunter College Elementary School students did their bit, too. The girls in the top image collect "Pennies for Defense." Below, from left to right, Betsy Asher, Lawrence Levine, and Bobby Berger add newspapers and bottles to the collection bin, c. 1943.

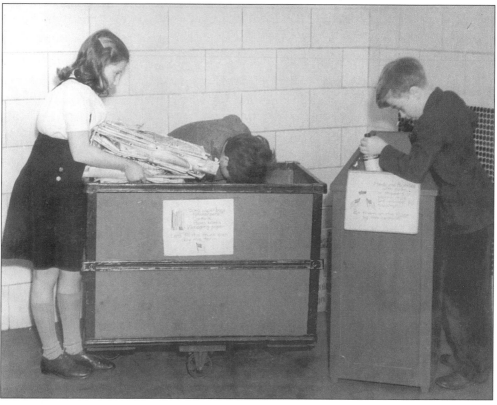

Hunter students collected money that bought food wholesale through shopkeeper Louis Rossi. The food was shipped directly to schools, orphanages, and refugee centers through CARE (Cooperative for American Remittances to Europe), *c.* 1945.

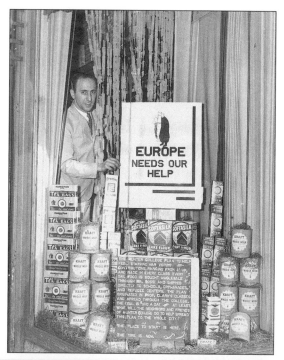

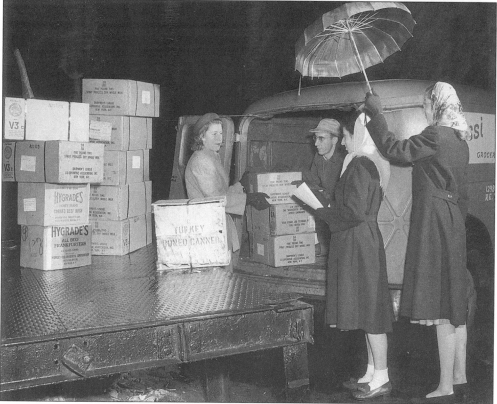

Hunter students help count and load boxes of food for shipment in this *c.* 1945 image.

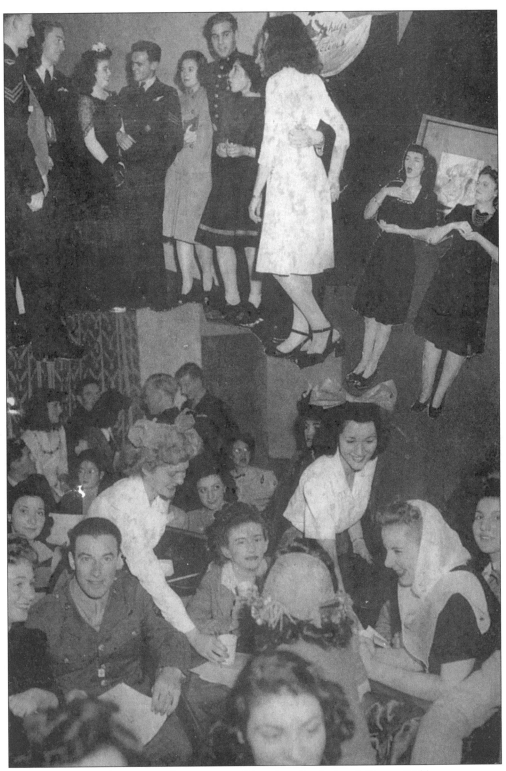

Hunter College students created a montage of Freedom Festival activities, *c.* 1944.

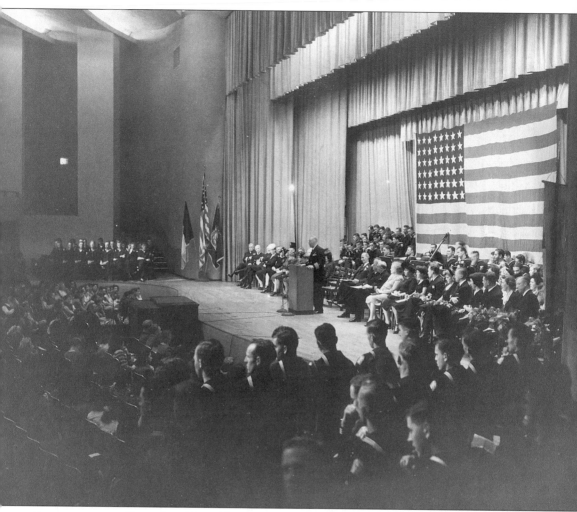

At a ceremony on November 15, 1944, Hunter officially sponsored six ships of the Amphibious Command. (Official U.S. Navy photograph.)

Marine air reservists happily sample cookies baked by home economics students for the armed forces here and overseas. Seen here, from left to right, are Tech. Sgt. Herbert Anderson, Geraldine Orio, Josephine Damiani, and MSgt. Kenneth L. Bergstedt, *c*. 1944.

A sorority dance at Roosevelt House in the 1940s was called a military reception.

Five

FACULTY

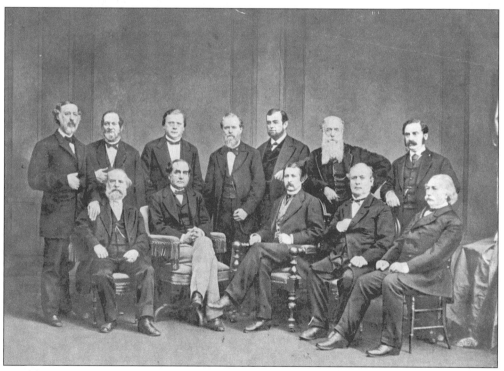

In 1869, a newly appointed New York City Board of Education voted to establish the Female Normal and High School as essentially a teacher-training school. Shown here, from left to right, are as follows: (front row) Magnus Gross, Isaac Bell, Richard L. Larremore, Timothy Brennan, and Nathaniel Sands; (back row) John H. Sherwood, Lorin Ingersoll, Thomas Murphy, Bernard Smyth (president), William E. Duryea, William Wood, and Samuel A. Lewis.

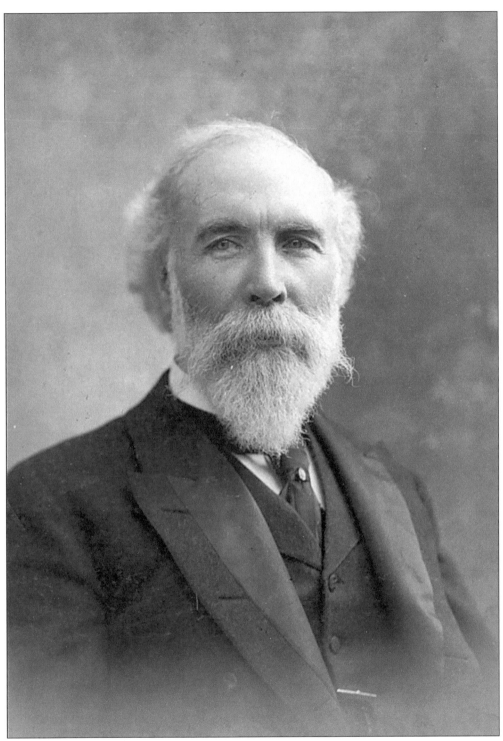

Dr. Thomas Hunter was the first president of the Female Normal and High School. He served as president until 1906. Hunter College was named for him in 1914. This photograph was taken in 1870.

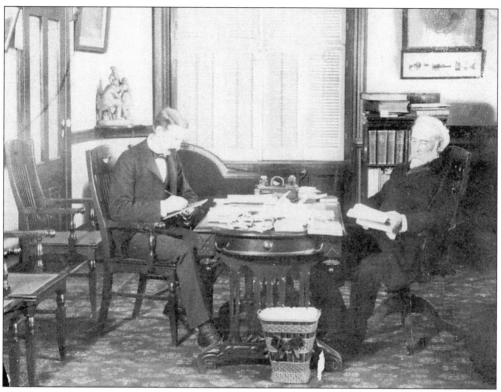

Dr. Thomas Hunter is shown here in his office with his secretary, *c.* 1905.

Lydia Wadleigh, shown here *c.* 1890, was named
the first superintendent of the new Normal School.

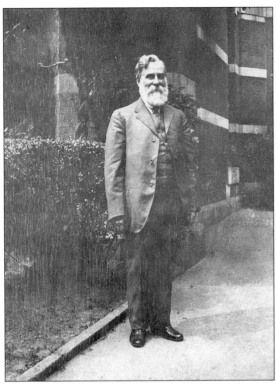

Prof. Joseph Gillet briefly served as acting president of the school, succeeding Dr. Thomas Hunter. Gillet died in office after surgery for appendicitis. He had been a faculty member of Hunter College since its opening almost 40 years earlier. A senior professor, he taught mathematics and physics. Gillet Hall on the Bronx Campus was named for him. He is seen here in a photograph taken in 1904.

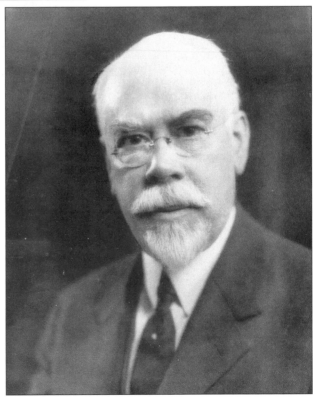

Dr. George Samler Davis served as president from 1908 to 1929. Davis Hall on the Bronx Campus bears his name. This photograph shows him c. 1920.

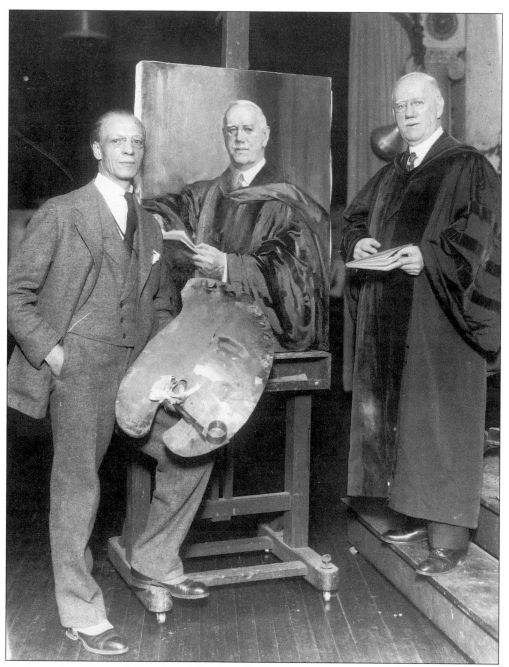

Dr. James M. Kieran, right, president of Hunter College from 1929 to 1933, poses with his portrait, painted c. 1930 by John C. Johansen. The portrait was presented to the college by the student body. During Kieran's presidency, construction began on the Bronx Campus buildings.

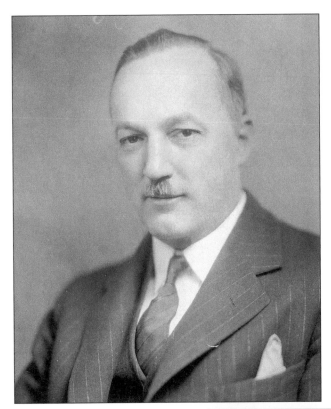

Dr. Eugene Colligan served as president from 1933 to 1940. In 1935, Columbia University awarded him its University Medal for Excellence in recognition of his service to the cause of education. Prior to his presidency of Hunter College, Colligan was a teacher, a principal, and an associate superintendent of schools in New York City.

Dr. George N. Shuster, seen here c. 1950, was president from 1940 to 1960. He spearheaded the acquisition of the home of Pres. Franklin Roosevelt and his mother as an interfaith house for the use of Hunter students. He also founded the concert series and developed both the Division of Nursing Education and the graduate program that focused on training teachers of physically handicapped children.

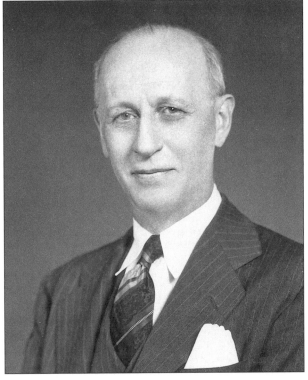

Photographed *c.* 1965, Dr. John J. Meng succeeded George Shuster as president and served until 1967. Meng joined the faculty in 1948 as a history professor and then became the first dean of administration, a position with executive control of the Bronx Campus.

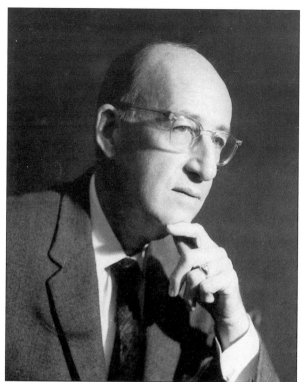

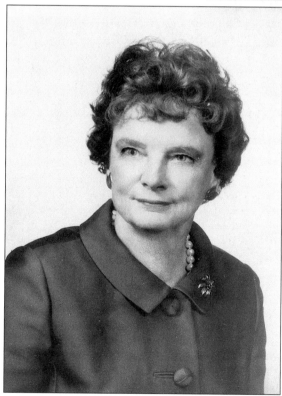

Dr. Mary Latimer Gambrell was acting president twice: first from April 1965 to October 1965 and then from September 1966 to January 1967. She served as president from February to July 1967. She was a history instructor at Hunter until 1948 when, as a full professor, she chaired the department. As dean of faculties from 1961 to 1966, she planned for the independence of the Bronx Campus and acquired the Bellevue School of Nursing with its residence hall.

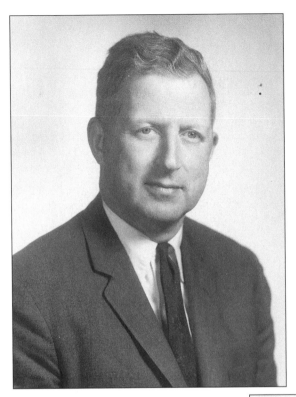

During the presidency of Dr. Robert Cross, from 1967 to 1969, the basic organization of the college was divided into four divisions: sciences and mathematics, humanities and arts, social sciences, and the education program. Dr. Cross launched the Institute (now School) of Health Sciences, the Department of Black and Puerto Rican Studies, and the SEEK (Search for Education, Elevation, and Knowledge) program.

Dr. Jacqueline Wexler, a former nun, was said to have "kept the College whole" during the Vietnam era and the New York City fiscal crisis. As president between 1970 and 1979, she saw the architectural plans drawn for the Twin Towers, the Women's Studies program launched, and the Hunter Senate established with student representation. She is pictured here *c.* 1974.

During Dr. Donna Shalala's presidency, from 1980 to 1988, the college's spirit and physical plant were renewed. The Twin Towers were built and the Social Work and Brookdale facilities were renovated. Graduate enrollment grew, an employee assistance program was begun, and the Student Services program was established, including a child care center. In 1993, Dr. Shalala joined Pres. Bill Clinton's cabinet as secretary of Health and Human Services. She is seen here *c.* 1987.

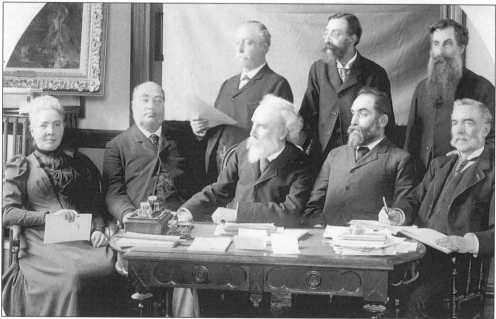

The 1893 college faculty consisted of the following, from left to right: (front row) Eliza Woods, superintendent and professor of ethics; Dr. Arthur H. Dundon, English literature, Latin, and Greek; Dr. Thomas Hunter, president and professor of intellectual philosophy; Prof. Isidor Keller, German and literature; and Prof. Eugene Aubert, French and literature; (back row) Dr. George Mangold, music; Prof. Edward Hartsink Day, natural science; and Prof. Joseph A. Gillet, mathematics and physical science.

Paul LeClerc, president of Hunter College from 1988 to 1993, revitalized the library and established the Hunter College Foundation for the financial support of the school. He also involved Hunter in community health activities, especially those fighting AIDS and drug addiction. He is pictured here backstage at the Sylvia and Danny Kaye Playhouse at Hunter. (Hunter College Office of Publication.)

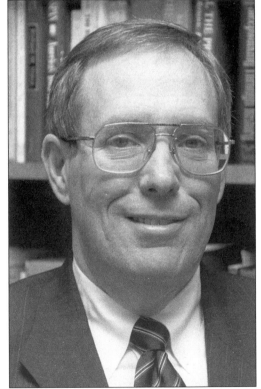

Dr. David A. Caputo is the current president of Hunter College. He came to Hunter from Purdue University, where he was a professor of political science and the dean of the School of Liberal Arts. (Hunter College Office of Publications, 1999.)

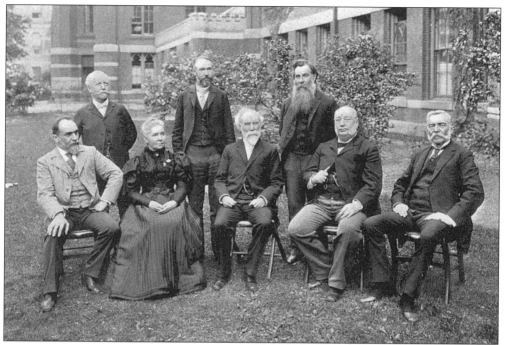

Dr. Thomas Hunter is seated in the center of this *c.* 1898 faculty photograph. Prof. Eliza Woods sits to his right and Prof. Arthur Dundon sits to his left. Prof. Joseph Gillet stands on the right.

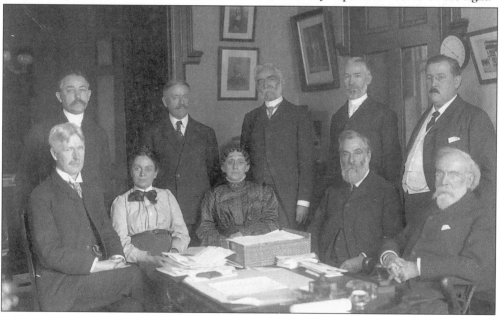

This 1905 faculty photograph shows, from left to right, the following: (front row) Prof. George Whicher, Latin and Greek; Prof. Helen Gray Cone, English; Prof. Laura Leal, ethics department and superintendent; Prof. Joseph Gillet, physics and mathematics; and Dr. Thomas Hunter, president; (back row) Prof. Henry Fleck, music; Prof. James Kieran, pedagogy and psychology; Prof. Eugene Aubert, French; Prof. Edward Burgess, natural sciences; and Prof. Carl Kayser, German.

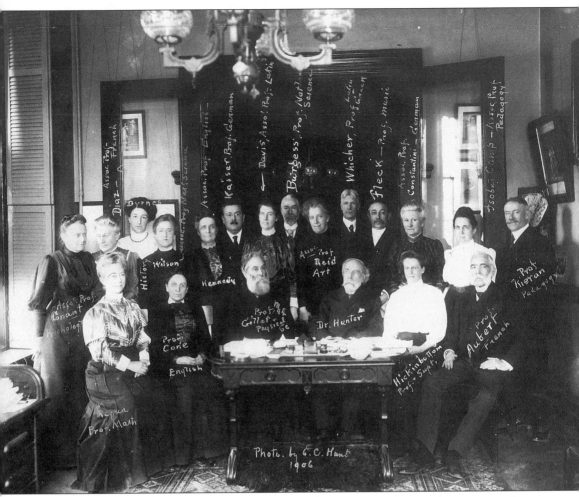

The 1906 faculty, from left to right, are as follows: (front row) Prof. Emma M. Requa, mathematics; Prof. Helen Gray Cone, English; Prof. Joseph Gillet, physics and mathematics; Dr. Thomas Hunter, president; Prof. Annie E. Hickinbottom, superintendent; and Prof. Eugene Aubert, French; (back row) Assoc. Prof. Emily Ida Conant, psychology; Assoc. Prof. Diaz, French; Clara Byrnes, history; Assoc. Prof. Watson, natural sciences; Assoc. Prof. Mary Kennedy, English; Prof. Carl Kayser, German; Assoc. Prof. George Samler Davis, Latin; Prof. Edward Burgess, natural sciences; Assoc. Prof. Reid, art; Prof. George Whicher, Latin and Greek; Prof. Henry Fleck, music; Assoc. Prof. Frederica Constantini, German; Assoc. Prof. Isobel Camp, pedagogy; and Prof. James Kieran, pedagogy.

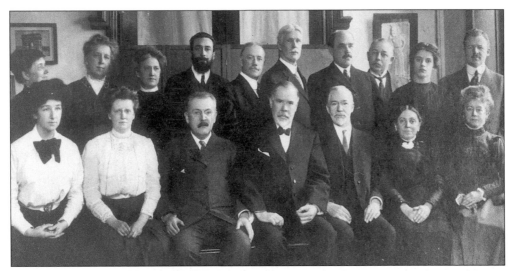

The 1910 faculty included, from left to right, the following: (front row) Prof. Clara Byrnes, sociology and English; Prof. Annie E. Hickinbottom, superintendent and dean of students; Prof. Carl M. Kayser, German; Prof. George Samler Davis, president; Prof. Edward Burgess, natural sciences; Prof. Helen Gray Cone, English; and Prof. Emma M. Requa, mathematics; (back row) Prof. Mary Kennedy, English; Prof. M. Christine Reid, art; Prof. Margaret B. Wilson, physiology and hygiene; Prof. Henri Borgy, French; Prof. James Michael Kieran, education; Prof. George Meason Whicher, classics; Prof. Edgar Dawson, history; Prof. Henry T. Fleck, music; Prof. Marjorie Burr Sargent, speech and English; and Prof. Lewis Hill, physics.

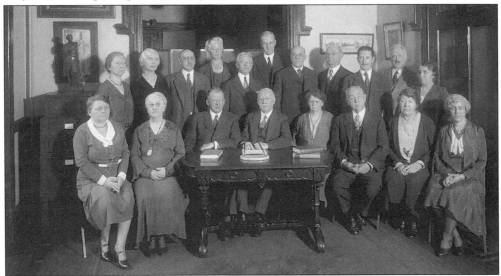

The c. 1932 department heads, from left to right, are as follows: (front row) Prof. Blanche Williams, English; Prof. Margaret Wilson, physiology; Prof. Lewis Hill, physics; Prof. James Kieran, president; Prof. Annie Hickinbottom, dean; Prof. Henry Fleck, music; Prof. Margaret Graham, biological sciences; and Prof. Claudine Gray, Romance languages; (back row) Prof. Henrietta Prentiss, speech and dramatics; Prof. Mary Higgins, education; Prof. Ernst Reiss, classics; Prof. Mabel Taylor, physical education; Prof. Adolph Busse, German; Prof. Edward Lehnerts, geology; Prof. Edgar Dawson, history and social sciences; Prof. Charles Moore, chemistry; Prof. Broderick Cohen, director of evening session; Prof. Joseph Chase, art; and Prof. Lao Simons, mathematics.

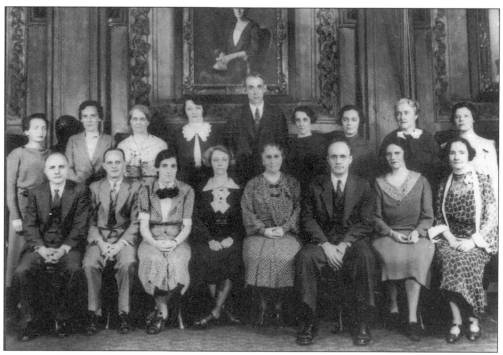

The Mathematics Department in 1938 included, from left to right, the following: (front row) Louis Weisner; Hobart Bushey; Laura Guggenbuhl; Marguerite Darkow; Lao G. Simons, chairman; Lester S. Hill; Mina Rees; and Marie Whelan; (back row) unidentified, Jewell H. Bushey, unidentified, Helen Kutman, A. Day Bradley, R. Lucile Andersen, Mary K. Landers, Isabel McLaughlen, and unidentified.

Helen Grey Cone graduated from the Normal College in 1876 and, as a professor of English, became the head of the English Department in 1899. She was named Poet Laureate of the college and her poem "Fame" became the school's anthem. She is seen here c. 1910.

Dr. Jennie B. Merrill was a tutor of principles and history of education and of teaching at the Normal College from 1878 until 1896. She served as supervisor of New York City public kindergartens between 1896 and 1911.

Dr. Emily Ida Conant, professor of psychology and an early graduate of the Normal College, joined the first staff of the Training Department. She was later the first woman in New York to hold a doctorate in pedagogy. She is seen here c. 1905.

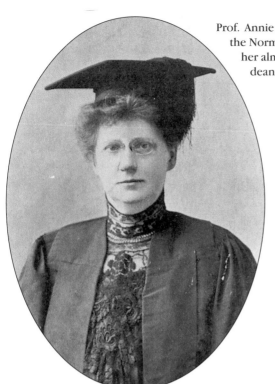

Prof. Annie E. Hickinbottom was an 1884 graduate of the Normal College. She was a professor of French at her alma mater, as well as lady superintendent and dean of students. She appears here *c.* 1910.

Emma M. Requa was member of the first graduating class of the Normal College in 1870. She remained at Hunter as a professor of mathematics. This image of her was taken *c.* 1900.

Julia Richman of the Normal College Class of 1872 started teaching at age 17. She was named principal of Public School 77 in New York and was later promoted to district superintendent of the city school system. She was instrumental in the establishment of special classes for "backward children" and schools for delinquents and truants. Julia Richman High School, which opened in 1923 at 68th Street and Second Avenue, was named in her honor. This photograph dates from *c*. 1920.

Jenny Hunter, Dr. Thomas Hunter's daughter, appears in this 1940 photograph. A graduate the Normal College, she established the Jennie Hunter Kindergarten and Training School in 1887 near the Hunter family residence in what is now Harlem.

Prof. Marguerite Jones served as head of the Department of Speech and Dramatics.

Ernest C. Hunt, photographed here in 1916, was secretary of Hunter College.

Ann Anthony graduated from the Normal College in 1904 and returned to her alma mater in 1911 as a teacher and then as a professor. In 1937, she was named acting dean of students in charge of the Bronx Campus. She was appointed dean of freshmen and sophomores at the Park Avenue building and then dean of students in 1946.

Prof. E. Adalaide Hahn, shown here c. 1930, was a graduate of Hunter College High School and a 1915 graduate of Hunter College. She later chaired Hunter's department of Latin and Greek. She was also a regular participant in Yale University's Linguistic Institute.

Dean Harry Levy was the veterans' adviser when the veterans were on the Bronx Campus. He was named dean of men when the Bronx Campus became coeducational. He was photographed here *c.* 1952.

Prof. John Henrik Clark of the Department of Black and Puerto Rican Studies was instrumental in developing courses in African and Afro-American history and culture at Hunter.

Ruth G. Weintraub graduated from Hunter in 1925 and returned to teach in the Political Science Department. By 1951, she was a full professor and in 1956, was named dean of graduate studies in the Arts and Sciences. She was also the founding dean of the Division of Social Sciences.

Kathryn Hopwood was dean of students after Dean Ann Anthony retired.

Richard Huber, shown here *c.* 1960, was director of the School of General Studies. He also headed the Hunter College Center for Lifelong Learning.

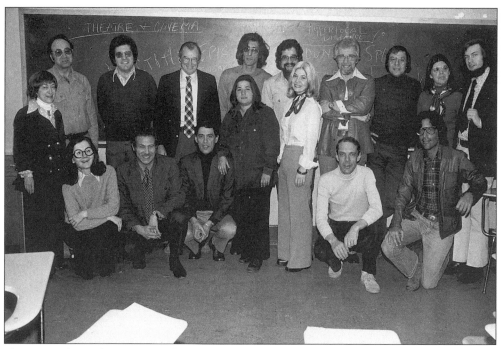

This image shows the Hunter College Department of Theater and Cinema.

Six
ACTIVITIES

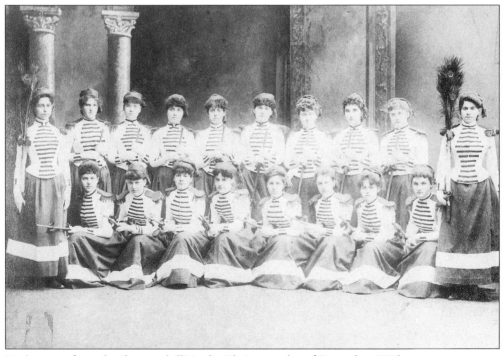

Students perform the "broom drill" in the Christmas play of December 1884.

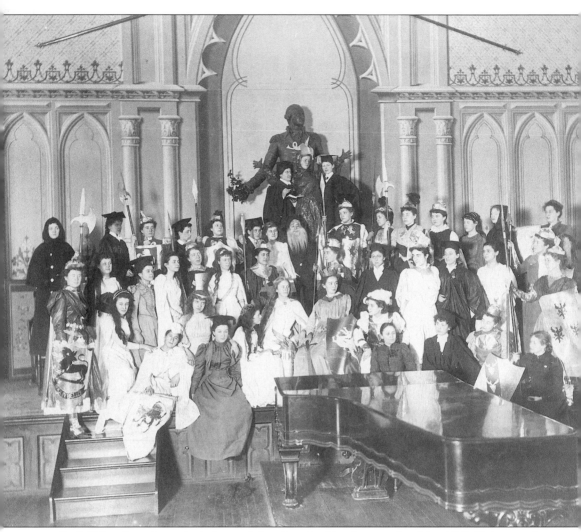

Prof. Helen Grey Cone sits in front of the piano in this photograph of the 1893 Christmas play.

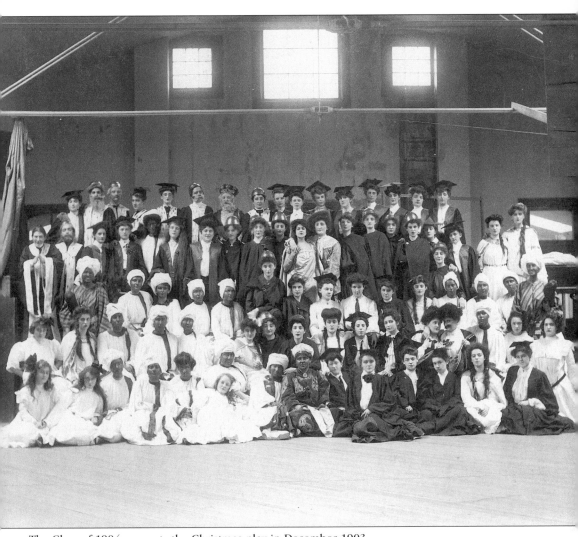

The Class of 1904 presents the Christmas play in December 1903.

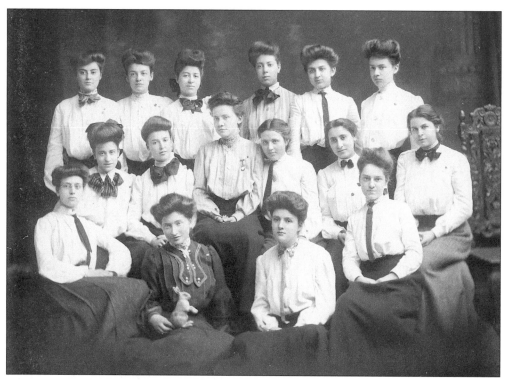

Epsilon Zodiac sorority poses for a photograph in 1903.

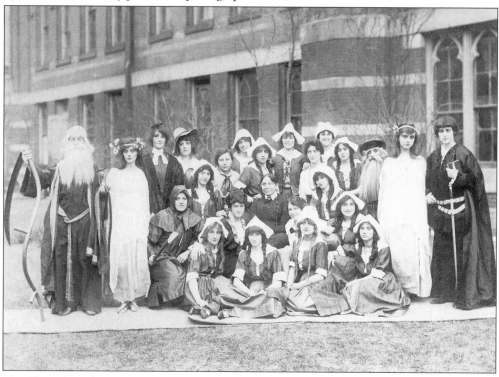

The Class of 1914 presents a Shakespeare masque for the 350th anniversary of the bard's birth.

In 1916, on the tercentennial of Shakespeare's death, students presented *Judith Shakespeare*. Performers included Ethel Solomon, Leslie Illig, Dorothy Miller, Gertrude Hackes, Billie Rice, Grace Nunn, Wilhelmina Thoma, Clara Auerbach, and Etta Scully.

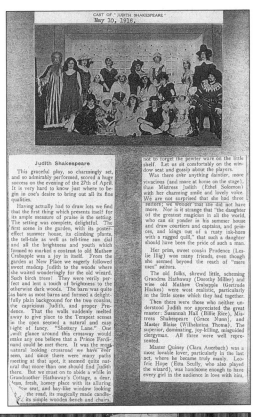

Judith Shakespeare

This graceful play, so charmingly set, and so admirably performed, scored a huge success on the evening of the 27th of April. It is very hard to know just where to begin in one's desire to bring out all its fine qualities.

Having actually had to draw lots we find that the first thing which presents itself for its ample measure of praise is the setting. The setting was complete, delightful. The first scene in the garden, with its poster-effect summer house, its climbing plants, the tell-tale as well as tell-time sun dial and all the brightness and youth which formed so marked a contrast to old Mathew Crabapple was a joy in itself. From the garden at New Place we eagerly followed sweet madcap Judith to the woods where she waited wonderingly for the old wizard. Such birch trees! They were verily perfect and lent a touch of brightness to the otherwise dark woods. The barn was quite as bare as most barns and formed a delightfully plain background for the two cousins, the capricious Judith, and proper Prudence. That the walls suddenly melted away to give place to the Tempest scenes in the open seemed a natural and easy flight of fancy. "Shottery Lane." One swift glance around this crossway would make any one believe that a Prince Ferdinand could be met there. It was the most natural looking crossroad we have ever seen, and since there were many paths meeting at that spot, it seemed quite natural that more than one should find Judith there. But we must on to abide a while in Grandmother Hathaway's Cottage, a dear, clean, fresh, homey place with its alluring low seat, and bay-like window looking on the road, its magically made candle, its simple wooden bench and chairs,

not to forget the pewter ware on the little shelf. Let us sit comfortably on the window seat and gossip about the players.

Was there ever anything daintier, more vivacious (and more at home on the stage), than Mistress Judith (Ethel Solomon) with her charming smile and lovely voice. We are not surprised that she had three suitors; we wonder that she did not have more. Nor is it strange that "the daughter of the greatest magician in all the world, who can sit yonder in his summer house and draw courtiers and captains, and princes, and kings out of a rusty ink-horn with a ragged quill," that such a daughter should have been the pride of such a man.

Her prim, sweet cousin Prudence (Leslie Illig) won many friends, even though she seemed beyond the reach of "mere men" suitors.

The old folks, shrewd little, scheming Grandma Hathaway (Dorothy Miller) and wise old Mathew Crabapple (Gertrude Hackes) were most realistic, particularly in the little scene which they had together.

Then there were those who neither understood Judith nor appreciated the great master: Susannah Hall (Billie Rice), Mistress Shakespeare (Grace Nunn), and Master Blaise (Wilhelmina Thoma), The superior, dominating, joy-killing, misguided clergyman. All three were well represented.

Master Quiney (Clara Auerbach) was a most lovable lover, particularly in the last act, where he became truly manly. Leofric Hope (Etta Scully, who also played the wizard), was handsome enough to have every girl in the audience in love with him,

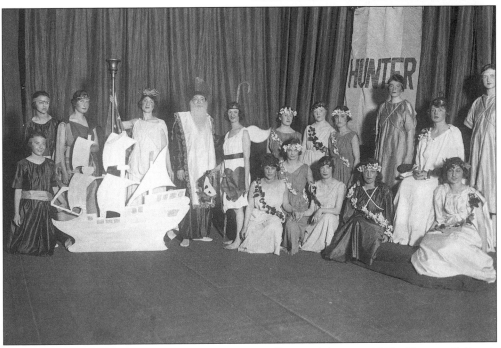

Students present a Festival of Gold for the College Jubilee in 1920, Hunter College's 50th birthday.

VARSITY 1940

presents

THE YELLOW JACKET

by George C. Hazelton and Benrimo

First Presentation in

THE HUNTER COLLEGE PLAYHOUSE

November Twenty-eighth
November Twenty-ninth
November Thirtieth

Varsity 1940 presented *The Yellow Jacket*,
"a Chinese play done in the Chinese manner."

THE YELLOW JACKET

by George C. Hazelton and Benrimo

A Chinese Play Done in the Chinese Manner
In Three Acts

CAST

(in the order of their appearance)

Property Man	Lillian Dong
Chorus	Selma Silverman
Wu Sin Yin, *Governor of the Province*	Miriam Ghidalia
Due Jung Fah, *second wife to Wu Sin Yin*	Rosalyn Finke
Tso, *maid to Due Jung Fah*	Sylvia Kissel
Tai Fah Min, *father to Due Jung Fah*	Laura Kessler
Chee Moo, *first wife to Wu Sin Yin*	Florence Richter
Lee Sin, *a farmer*	Carmel Ajello
Suey Sin Fah, *his wife*	Rosemarie Prockl
Ling Won, *a spirit*	Sallie Bucken
Wu Hoo Git, *young hero of the Wu family*	Betty Rehnstrom
Wu Fah Din, *The Daffodil*	Alberta Bell
Yin Suey Gong, *Purveyor of Hearts*	Betty Jean Hertz
Mow Dan Fah, *Peony Flower*	Georgette Rosenthal
Yong Soo Kow, *Hydrangea Flower*	Gena Piccione
See Quoe Fah, *Four-Season Flower*	Sallie Bucken
Chow Wan, *Autumn Cloud*	Sherry Jacobsen
Moy Fah Loy, *Plum Blossom*	Dorothy Grodner
See Noi, *nurse to Plum Blossom*	Martha Greenhouse
Tai Char Shoong, *father to Moy Fah Loy*	Margaret Vath
Widow Ching	Anita Fritz
Maid to Widow	Nora Weiner
Git Hok Gar, *Philosopher and Scholar*	Geraldine Manes
Loy Gong, *God of Thunder*	Lillian White
Kom Loi, *Spider*	Antoinette Scherer
Assistant Property Men and Attendants	Florence Brudney
	Edith Kroll
	Gertrude Eisenstadt
	Shirley Rappoport
	Nora Weiner
Musicians	Hilda Cohen
	Ruth Fromkes
	Margaret Hochman

Produced under the Direction of Arthur L. Woehl

There will be an Intermission of ten minutes between the acts.

96

Rip Van Winkle was the Varsity production in 1928. Included in the cast were Dorothy Gillam, Hilde Graf, Laura Pitkowsky, Sylvia Segale, Anne Bartley, Muriel Leahy, Celia Marshak, Jacqueline McNaughton, Helen Schiller, Rose Aronowitz, and Gladys Luschutz.

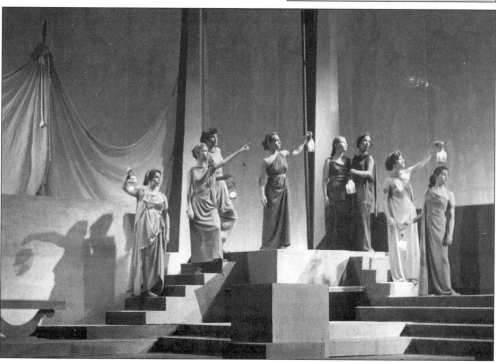

The Theater Workshop presents *Daughters of Atreus* in 1955.

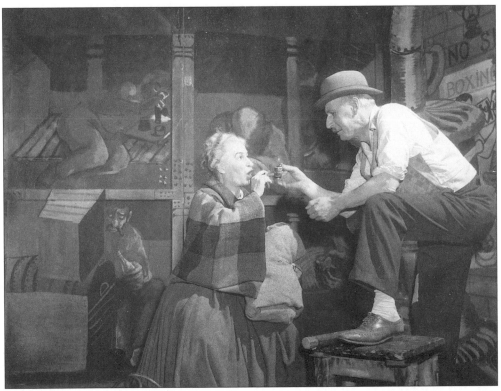

Hunter Pres. George Shuster, right, and college Dean Ann Anthony get into the act in this *c.* 1955 scene.

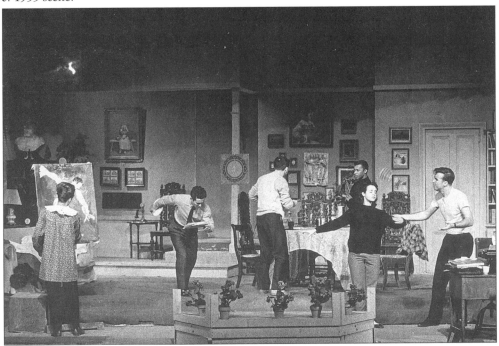

The Theater Workshop performs *You Can't Take It With You* in 1962.

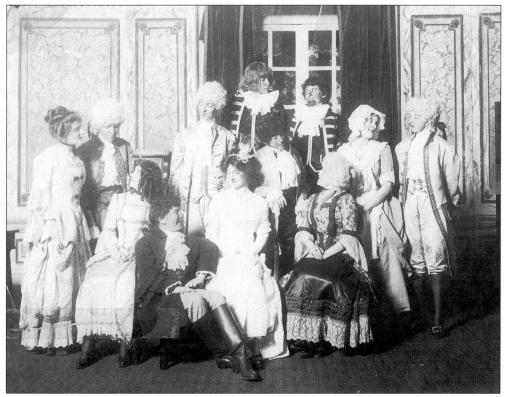

Hunter College High School was dramatic in 1913.

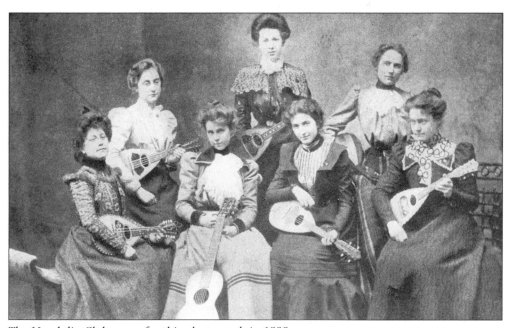

The Mandolin Club poses for this photograph in 1899.

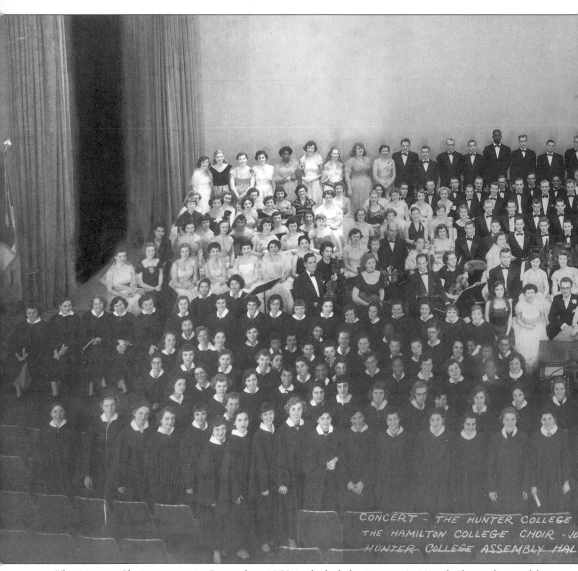

The Hunter Choir concert in December 1952 included the Women's Mixed Choir, directed by Anders Emile, and the Hamilton College Choir, directed by John J. Baldwin Jr. The Hunter Choir

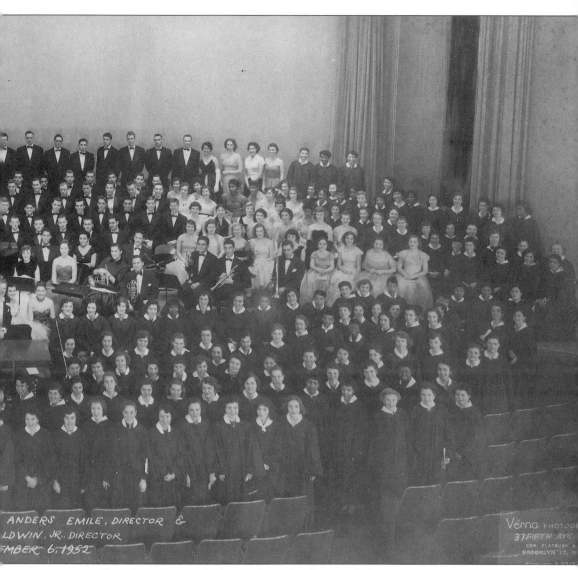

was open to all students. Singers had to audition for the Mixed Choir.

The Political Science Club poses for a photograph *c*. 1900.

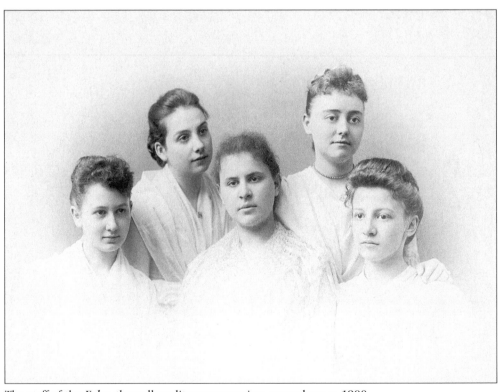

The staff of the *Echo*, the college literary magazine, poses here *c*. 1900.

At Roosevelt House, social secretary Mrs. Deiches, second from left, was the one to see when clubs or sororities needed to schedule a function there.

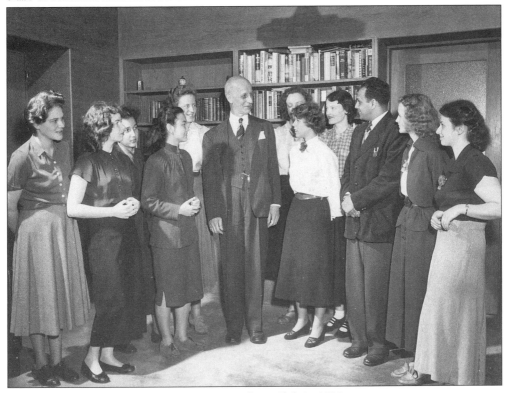

Pres. George Shuster poses with the Cosmopolitan Club in 1950.

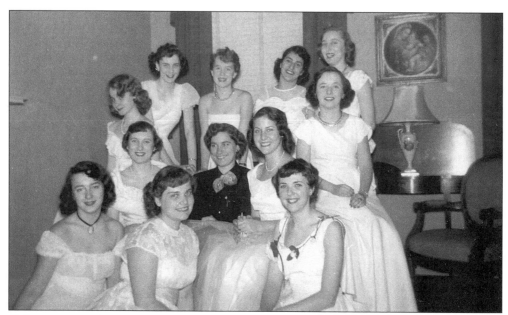

Alpha Gamma Delta sorority held an initiation, the Candlelight Feast of Roses, at the Hotel Abbey in 1949. Pictured here, from left to right, are as the following: (first row) Lydia Obierek, Frances McGregor, and Joan Blumer; (second row) Lorraine Rogal, adviser Inga Endres, and Louise Seneff; (third row) Eileen Walsh and Rhoda MacFarlane; (fourth row) Joan Thiele, Joan Dunseath, Ann Krikorian, and Dorothy Moran. (Courtesy of Frances McGregor Leister.)

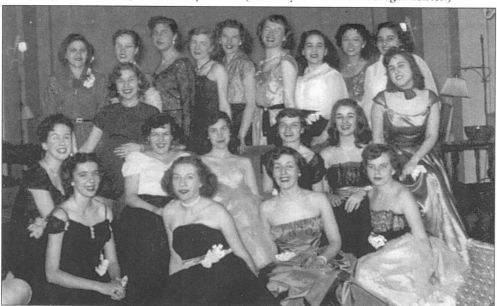

Alpha Sigma Rho sorority celebrates in 1950. Pictured here, from left to right, are the following: (first row) Margaret Zajac, Valerie Tresnowske, Alice Burgdorf, and Margaret Kegan; (second row) Eileen Coe, Janice Courtade, Selva Figueroa, Lorraine Mustoe, and Paula Nastold; (third row) Bruna Lenzovich and Geraldine Gonnella; (fourth row) Barbara Donadio, Marguerite Verrat, Cecelia Vitiello, Loretta Blaul, Joan Meyer, Bernice Blaul, Pia Volpe, and Terry Speciale. (Courtesy of Terry Speciale.)

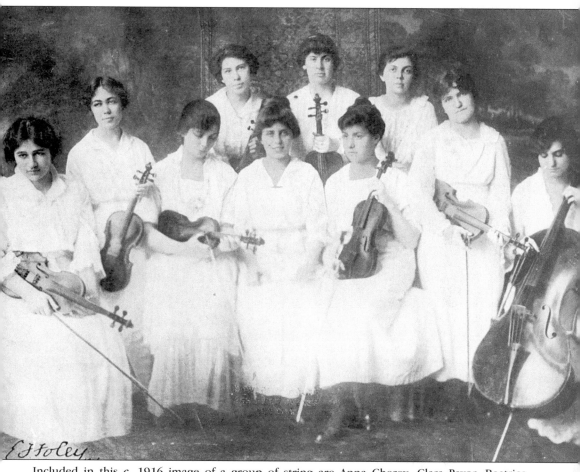

Included in this *c.* 1916 image of a group of string are Anna Cherey, Clara Payor, Beatrice Rosenthal, and Frances Lewitus. The group was "actively associated with 'just-before-Sing' days."

WINNERS ALL

	FIRST PLACE		SECOND PLACE	
Year	*Class*	*Theme*	*Class*	*Theme*
1917	'18	No costumes	'19	No costumes
1918	'18	No costumes	'20	No costumes
1919	'19	Chinese	'20	No costumes
1920	'20	Angels	'22	Railroad Train
1921	'22	Pirates	'21	Sailors
1922	'22	Oriental Peers	'23	Robin Hood
1923	'23	Scotch	'25	Wooden Soldiers
1924	'24	Dutch Cleansers	'25	Cavaliers
1925	'25	Negro Minstrels	'28	Sing Sing
1926	'28	Music Notes	'26	Roman Soldiers
1927	'28	Chinese Festival	'27	Peers of "Iolanthe"
1928	'28	Chauve Souris	'30	Negro Spirituals
1929	'29	Elizabethans	'30	Venetian Carnival
1930	'30	Naughty Nineties	'32	Egyptians
1931	'31	Hell's Populace	'32	Joan of Arc Film
1932	'33	Mother Goose	'32	Arabian Nights
1933	'35	West Point	'33	Electoral College
1934	'34	Spirit of the World	'35	Marionettes

An ebony baton with a silver tip and silver head was presented to the winning Sing by the Class of 1918, which won the first two Hunter College Sings.

1935	'35 Telephone	'37	Cosmetics
1936	'37 Rhythm Around the Clock	'36	Lady Luck
1937	'37 Seven Stages of Life	'39	Dance Swing
1938	'39 Satan Takes a Holiday	'38	Foods
1939	'39 Conquest	'40	Dreams
1940	'40 Swinging Hamlet	'41	Hercules
1941	'41 Hawaiian Serenade	'42	Sanity Fair
1942	'42 Sitting Bull Session	'43	Mihi Cura Futuri
1943	'44 One Third of a Ration	'43	International Lady
1944	'44 A Lad in '44	'45	Behind the Scenes
1945	'45 Rich Man, Poor Man	'46	Court of Modern Times
1946	'46 Season It	'47	From Who's Who
1947	'48 Back in '45	'47	Occidental Orienta
1948	'48 Freedom Train	'49	The Big Top-ic
1949	'49 School of Fort Knox	'50	An Artist's Life
1950	'51 Hosteling Hunterites	'50	Attune for Fiesta
1951	'52 As We Like It	'51	New York
1952	'52 The Roaring Twenties	'54	Love Through the Ages
1953	'53 Labor Pains	'55	Way Down Yonder
1954	'55 Bars and Stripes	'54	The Rebirth of a Nation
1955	'55 Behind the Trojan Curtain	'57	Jungle Jumble
1956	'56 7 Deadly You Know Whats	'58	Tempos
1957	'58 Power	'57	The Creation

An ebony baton, with a silver tip and silver band, is awarded annually to the winning *Sing* by the Class of 1918, victor of the first and second annual Hunter College *Sings*.

Sing was a popular activity each year, involving large student participation.

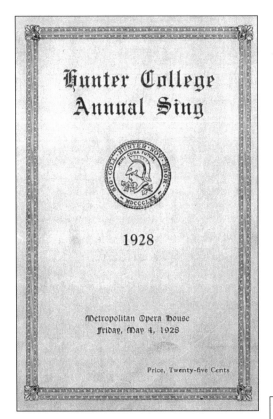

The Class of 1928 won first place with its theme of "Chauvre Souris" in Sing 1928, which was held at the Metropolitan Opera House.

23rd Annual

SING

of Hunter College

The Hippodrome
May 5, 1939 at 1:30 P. M.

In 1939, the Hippodrome was the setting for the 23rd annual Sing, which was won by the Class of 1939 with its theme of "Conquest."

Sing 1933 sported an eye-catching program cover. The Class of 1939 placed first with a theme of "West Point."

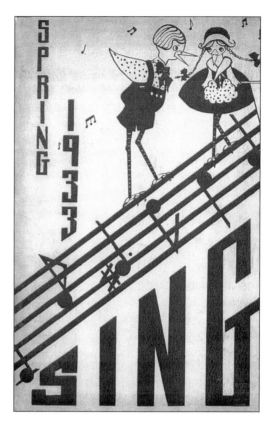

The Central Committee for 1933 Sing was comprised of, from left to right, the following: (front row) Florence White, Ethel Blaine, Mary Gori, Amelia Cox, and Florence Belmont; (middle row) Lena Di Perna, Nilda Miraglia, Ann Little, Sarah Weingart, Lillian Cohen, Marguerita Amendola, and Anna Weinstein; (back row) Margaret Houlahan, Mildred Ward, and Mary Kilker.

These freshman participated in Sing 1939, which was won by the senior class.

This montage includes bits and pieces of Sing 1946, which was won by the senior class. The winning theme was "Season It."

Sing 1958 produced an imaginative line drawing for its program cover. The winner was the senior class, with the theme "Emotion."

Seven

ATHLETICS

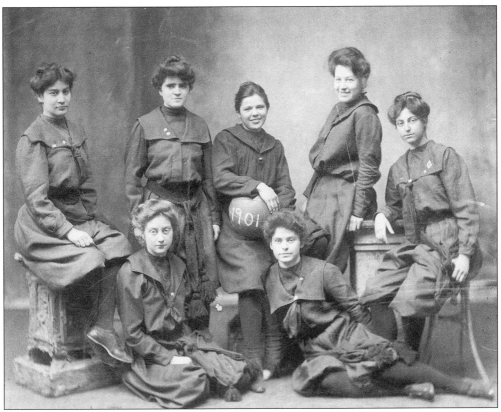

Some members of the varsity basketball team of 1901 pose here. Players included Anna Strickland, center; Nancy B. Kirkman, captain; Kathleen M. Murphy, left forward; Gertrude M. Earl; Lilly ?; Lillie ?, substitute right guard; Julia Hawley, right guard; Elsie Chalmers; Eleanor ?, left guard; Adelaide ?; and Helen Gray.

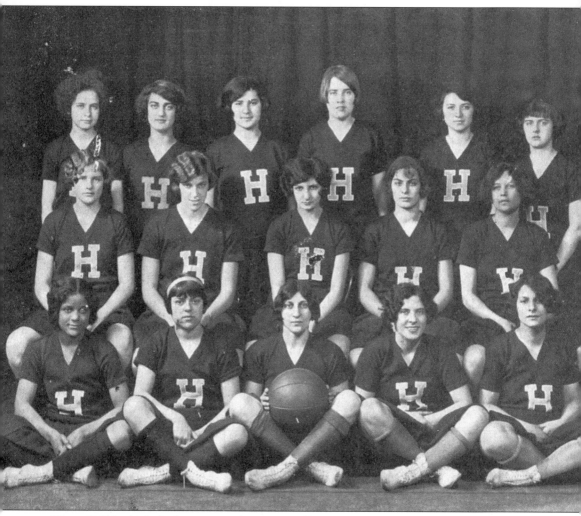

These 1925 basketball players wear their H proudly.

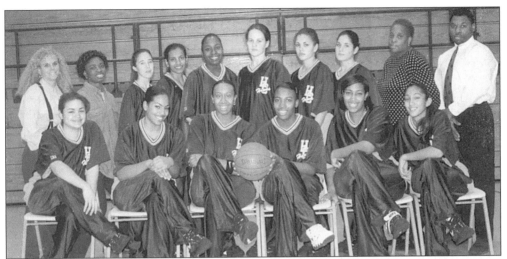

Jackie Meadow, back left, coached Hunter's 1996–67 basketball team. Among the team members pictured here are the following: (front row) Yaasmin Hooey, two-time City University of New York (CUNY) All Star, third from left; and Avryl Jonas, fourth from left; (back row) Suzette Henry, four-time CUNY All Star, second from left; Maria Kavourias, three-time CUNY All Star, third from left; Krisena Dass, fourth from the left; and Arthur Smith, assistant coach, far right. (Athletic and Recreation Programs Department.)

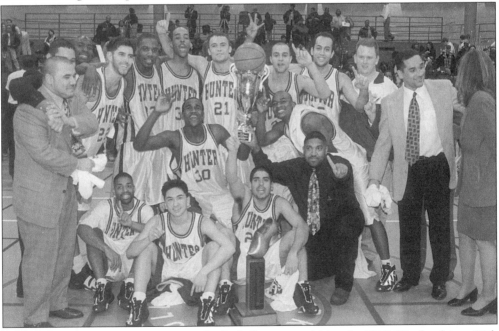

Dave Guzman, left, managed the men's basketball program during the 1997–98 school year. With Guzman are the following, from left to right: (front row) Troy Battle; Lorenz Albano; Demetrios Tsumutalis; and Curt Hall, student trainer, holding the CUNY championship trophy; (middle row) Lester Harry and George Brown; (back row) Mark Jerome and Derrick Canada, assistant coaches; Brian Palacio; Braheen Cotton, CUNY Most Valuable Player (MVP); Gypsy Pichardo; Chris Matesic; Stanley O'Neil; Albert Ramirez; Trainer Tom Buckley; Charles Cotto, assistant coach; and Terry Wansart, athletic director. (Athletic and Recreation Programs Department.)

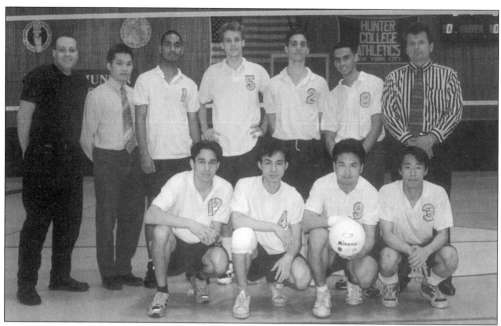

Dinu Dan, right, coached the men's 1996–67 volleyball team. Among the team members pictured here are the following: (front row) Yanqi Jiang, second from left; and Domenico Ri, far right; (back row) Ryan Kozlowski, fourth from left; and Alan Shurafa, fifth from left. (Athletic and Recreation Programs Department.)

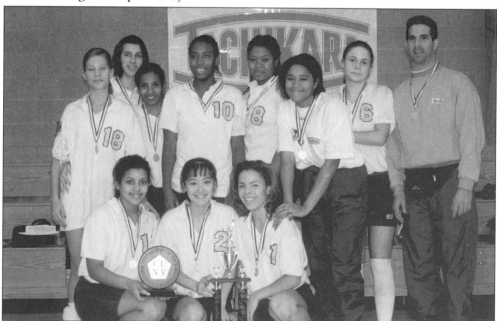

Among the team members pictured here are the following: (front row) Amelia Santos, 1997–78 National Collegiate Athletic Association (NCAA) Woman of the Year, right; (back row) Adele Steine, two-time CUNY MVP, second from left; Krishna Das, third from left; Avryl Jonas, fourth from left; Anna Wroblewska, CUNY MVP, second from right; and Jeff Lipton, coach, far right. (Athletic and Recreation Programs Department.)

Under the leadership of Coach Matt Burcaw, front, the women's tennis team won seven CUNY tennis championships between 1990 and 1996. (Athletic and Recreation Programs Department, 1994.)

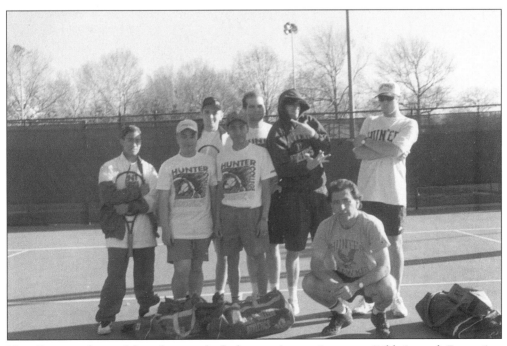

Matt Burcaw, front right, also coached the men's tennis team. (Athletic and Recreation Programs Department.)

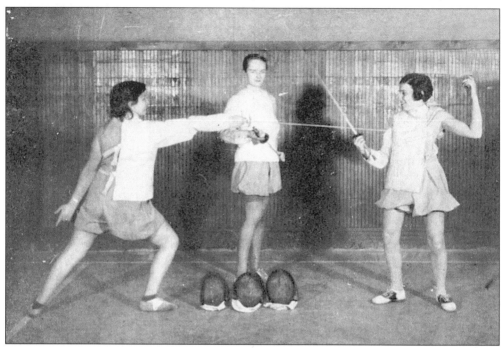

Women students practice fencing in this 1932 photograph.

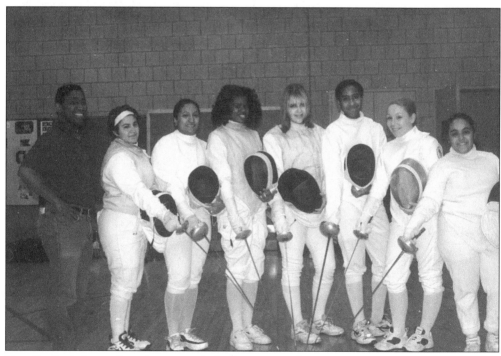

Max Catala, left, coaches the women's fencing team of 1997–78. Among the team members pictured here are Isabel Alvarez, All-Conference and All-Region winner, second from left; Jacqueline Smith, third from left; and Michelle Acosta, sixth from left. (Athletic and Recreation Programs Department.)

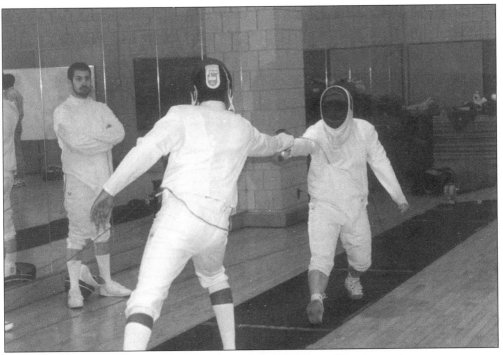

Men students fence in 1996. (Athletic and Recreation Programs Department.)

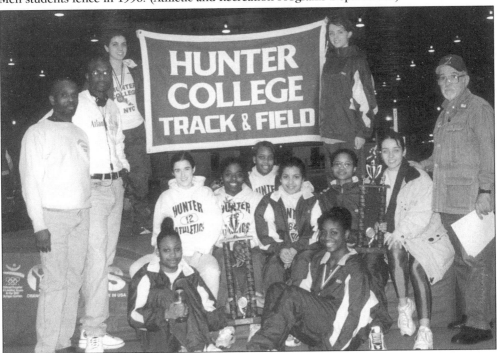

Ed Zarowin, far right, coached the women's indoor track CUNY champions (1996–67). Among the team members pictured here are the following: (front row) Samantha Wiltshire, right; (middle row) Joanne Fleurodir, right; (back row, holding up the banner) Rosalie Garziano, left; and Rachel Cleary, right. (Athletic and Recreation Programs Department.)

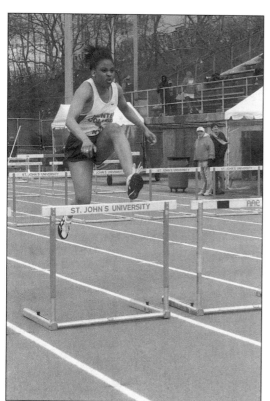

Michelle Nurse takes a hurdle at the CUNY championship meet. (Athletic and Recreation Programs Department.)

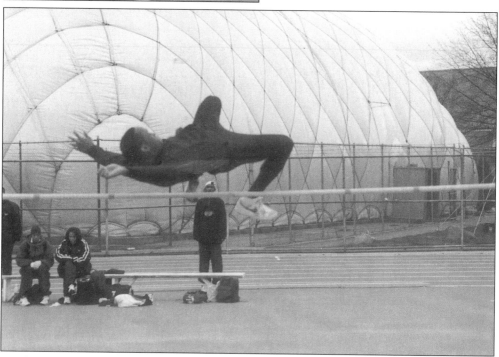

Nigel Franklin is at the high jump. He was National Champion twice, All-American four times, and All-American Triple Jump four times. (Athletic and Recreation Programs Department, 1997)

They are off and running at this men's track and field event. (Athletic and Recreation Programs Department, 1996–97.

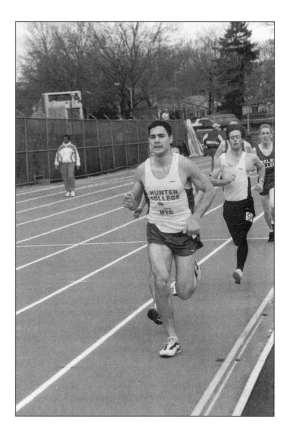

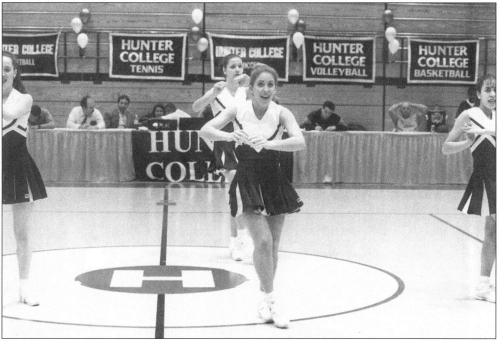

Cheerleaders boost the players' spirits. (Athletic and Recreation Programs Department.)

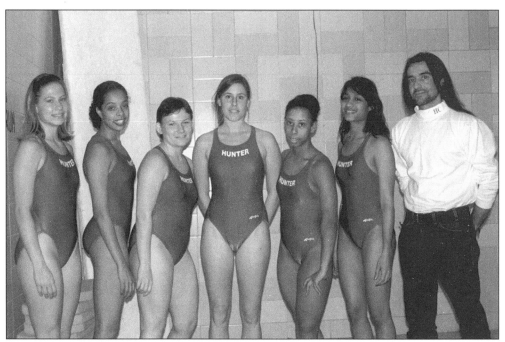

Pedro Santos, far right, coached the women's swim team, which included Connie Williamson, third from left, and Anne Grimes fourth from left. (Athletic and Recreation Programs Department, 1995–96.)

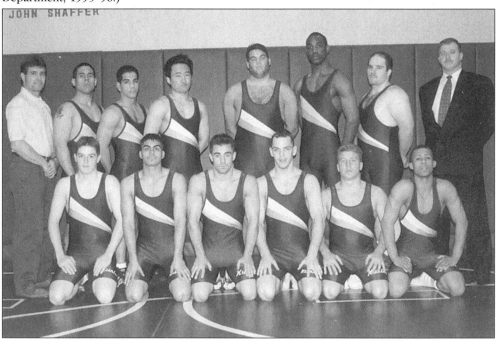

Wrestlers were coached by Bob Gaudenzi, assisted by Eric Kosics. Among the members are the following: (front row) Jack Granata, All American, third from left; and Tyga Maclan, right; (back row) Tom Holiday, NCAN All Qualifier, third from right. (Athletic and Recreation Programs Department, 1976–67.)

Eight

PEOPLE

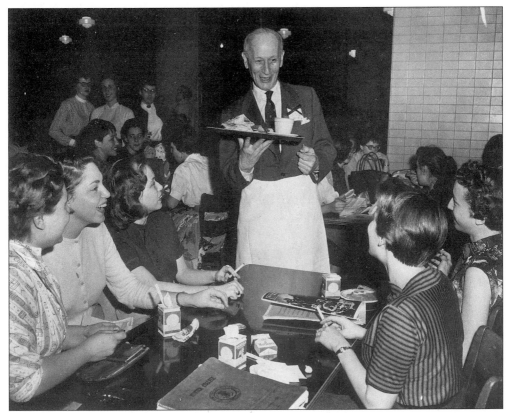

When Pres. George Shuster served students in the cafeteria, his waiter's tips went to the World University Service. (Copyright *c.* 1956 by the *New York Times*. Reprinted by permission.)

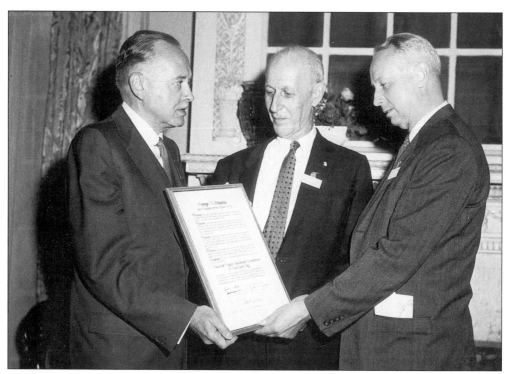

Pres. George Shuster, center, receives the Educator of the Year award in 1958.

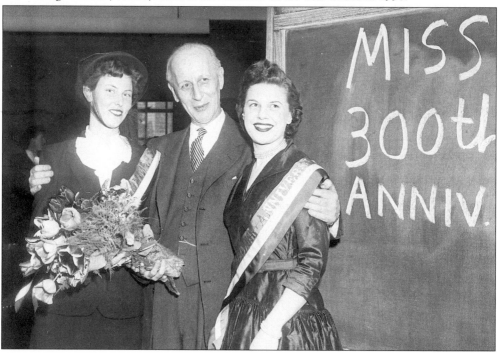

Celebrating the 300th anniversary of New York City, Hunter student Jill Oplinger, right, and Pres. George Shuster welcome Dutch student Meike Meurs, who was brought to the city by the Association of Neighbors and Friends of Hunter College.

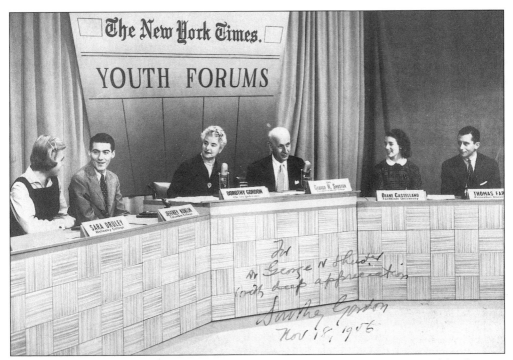

Pres. George Shuster, fourth from left, takes part in the Youth Forums sponsored by the *New York Times*. (Copyright *c.* 1956 by the *New York Times*. Reprinted by permission.)

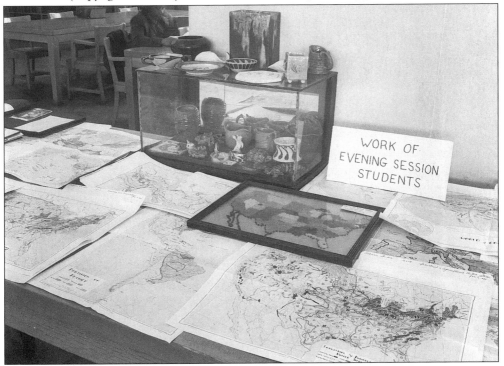

The work of previous Evening Session students is displayed at the beginning of a semester. Evening classes were inaugurated *c.* 1918.

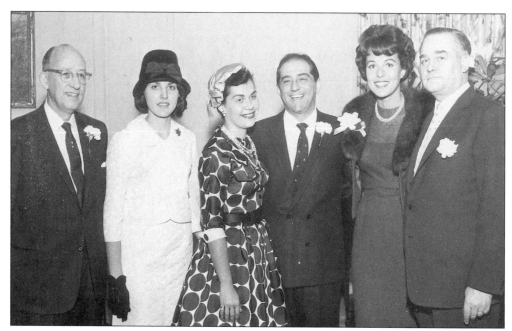

Used by college organizations, the Roosevelt House celebrated its 16th birthday on March 15, 1960. Dignitaries attending included, from left to right, Pres. John Meng, student Barbara Krajchir, Mrs. Robert Merrill, Robert Merrill of the Metropolitan Opera, Miss America of 1945 Bess Myerson, and French cultural consular officer M. Edouvard Morot-Sir.

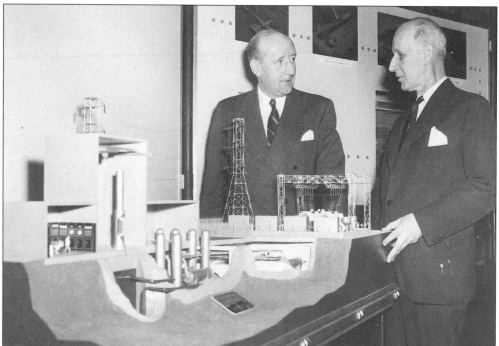

Atomic Industrial Forum Inc. arranged an exhibition at Hunter on peaceful applications of atomic energy for the U.S. Information Agency in December 1954. Shown are Pres. George Shuster, right, and Mr. Stone of Stone and Webster.

Hunter graduate Regina Resnick played the role of Carmen at the Vienna Statsopera. In 1991, she was awarded an honorary doctor of humane letters, *Honoris Causa*, for her "creativity and open-hearted generosity to a vast public."

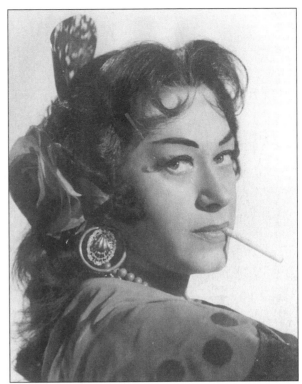

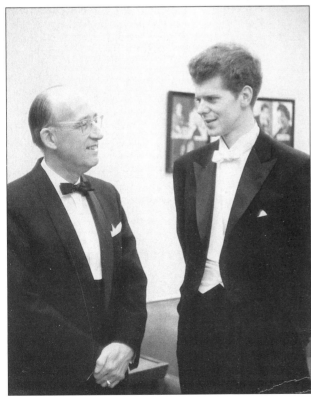

Pres. John Meng converses with Van Cliburn at the pianist's concert at Hunter in March 1962.

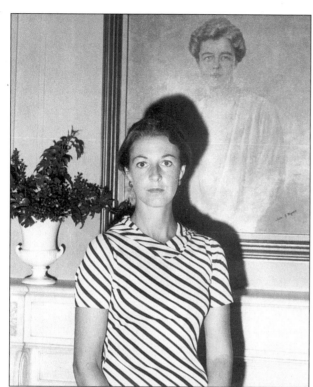

Actress Jane Alexander stands before a portrait of Eleanor Roosevelt at the Roosevelt House. The actress portrayed the former first lady in a production at Hunter in October 1974.

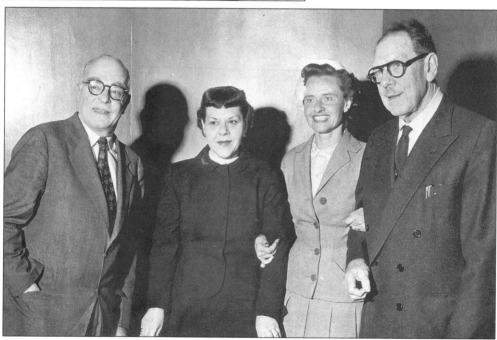

Class of 1938 member Rose J. Orente, second from left, receives first prize in the national verse-play contest sponsored by the Academy of American Poets (AAP) in April 1957. Pictured with her, from left to right, are author Thornton Wilder, AAP President Mrs. Hugh Bullock, and playwright Maxwell Anderson.